ILLUSTRATED TALES OF
LANCASHIRE

DAVID PAUL

AMBERLEY

Acknowledgements

As is always the case, it would be nigh on impossible to thank all the many people who have helped me in the writing of this book. However, I must make special mention to Revd Brian Newns, parish priest at St Oswald's and St Edmund Arrowsmith, Ashton-in-Makerfield; the owner of Plumpton Hall, near Ulverston; staff at Colne Library; the wardens at St Margaret's Church, Hornby; Mr Les Tickle at St Oswald's Church, Winwick; and Russell Currie, site manager at Mellor Brook, all of whom have helped in different ways with the research for this book. I must also thank my wife Janet for willingly giving her time and assistance in accompanying me when photographing the various locations of the legends.

Also, with reference to some of the sketches included in the text, I wish to state that despite prolonged and exhaustive enquiries, tracking down some copyright holders has not been possible.

Finally, while I have tried to ensure that the information is factually correct – a daunting task in itself – any errors or inaccuracies are mine alone.

First published 2018

Amberley Publishing
The Hill, Stroud
Gloucestershire, GL5 4EP

www.amberley-books.com

Copyright © David Paul, 2018

The right of David Paul to be identified as the Author
of this work has been asserted in accordance with the
Copyrights, Designs and Patents Act 1988.

British Library Cataloguing in Publication Data.
A catalogue record for this book is available from the British Library.

ISBN 978 1 4456 8239 6 (paperback)
ISBN 978 1 4456 8240 2 (ebook)

Origination by Amberley Publishing.
Printed in Great Britain.

Contents

Introduction

Sadly, many popular legends are now disappearing from our oral landscape, perhaps because the tradition of local storytelling itself is becoming a feature of former times – from before the age of television, computers and even radios. Many legends were lost when the ancient mansions with which they were associated fell into disrepair, while others have faded because the individuals who were wont to repeat them to their descendants have long-since passed on. Societal changes and the way in which information is networked also significantly accounts for the demise of this form of communication.

Fortunately, the county of Lancashire is rich in folklore and traditions, but just how or when many of these popular legends originated cannot be ascertained. Their origins are lost in the mists of time, without any definitive provenance. It is apparent that many have been developed as a result of some unusual phenomenon that could not be accounted for, or when a supposedly supernatural event has occurred.

It is hoped that the stories that follow may preserve, in some small way, a few of the more important legends, traditions and folklore of the old county of Lancashire. The book does not purport, in any way, to be an academic text, but is aimed at the general reader.

February 2018

Father Arrowsmith's Hand

In the Church of St Oswald and St Edmund Arrowsmith in Ashton-in-Makerfield there is a preserved human hand that, so it is claimed, has miraculous powers. The hand was said to have belonged to Father Edmund Arrowsmith. Arrowsmith became a member of the Society of Jesus and, accordingly, refused to take the Oath of Supremacy. In 1628 he was tried on a charge of high treason. He was accused of being a priest and a 'perverter in religion'. He was found guilty and the usual sentence was meted out to him: hanging, drawing and quartering. When passing sentence, the judge made the following pronouncement: 'Know shortly thou shalt die aloft between heaven and earth, as unworthy of either, and may thy soul go to hell with thy followers.' But, when the sentence was passed, nobody would perform the task of executing him. Eventually, a local butcher said that, for £5, he could persuade one of his servants to do it. But, on hearing what his master had volunteered him to do, the servant ran away and was never seen again. Finally, one of the prisoners in the castle was coerced into performing the execution.

A letter written by Mr Henry Holme makes reference to certain relics of the priest's body, but fails to mention Arrowsmith's hand. There followed what is now a widely accepted account in which it was suggested that following Arrowsmith's demise, his body was dismembered and then one of his friends cut off his charred right hand. It is believed that the hand was initially kept in a linen cloth within a box, but was later preserved in a white silk bag. Lady Burton later had it encased in a silver casket.

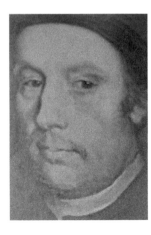

Father Arrowsmith.

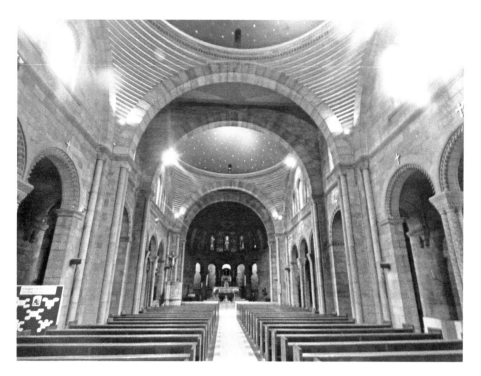

Above: Interior of
St Oswald and St Edmund
Arrowsmith.

Right: Church of
St Oswald and St Edmund
Arrowsmith.

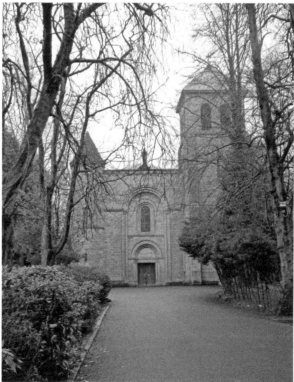

One of the first references to the hand's mystical powers relates to the death of the custodian of the hand, who had called for his lawyer on his deathbed in order to make his final will, but before arriving the custodian died. There was then lengthy deliberation as to whether the hand could perform a miracle on the corpse. It was then alleged that when the dead man's body was rubbed with the hand, the man was revived enough in order for him to sign his last will and testament.

After the funeral the daughter of the deceased produced an unsigned will, which purported to leave the property to her and the dead man's son; but, the lawyer produced the later will that had been signed with the aid of the hand. As a result, the lawyer was awarded the property. There was then a heated altercation between the lawyer and the dead man's son, which resulted in the lawyer being wounded. The young son fled and was never seen again. Shortly afterwards the daughter also disappeared, and she too was never seen again. Many years later, when a gardener was digging in the grounds, he uncovered the skull of the daughter. Following that revelation, the ghost of the murdered daughter always appeared before the lawyer wherever he fled. Rumour had it that the discredited lawyer spent most of his remaining days somewhere in Wigan, suffering from despair and remorse. It is said that the ghost of the young lady can still be seen in one of the hall's rooms, and sometimes passers-by have seen her ghost near to where her remains were unearthed.

A number of similar stories concerning the powers of the hand have been recorded since that time. Indeed, many still held to the belief that the dead hand had miraculous powers, a fact that was borne out in an entry in the Catholic Directory of 1892, wherein it states: 'Those who wish to venerate the "Holy Hand" will have an opportunity of satisfying their devotion on any day after mass.'

Location: WN4 9NP

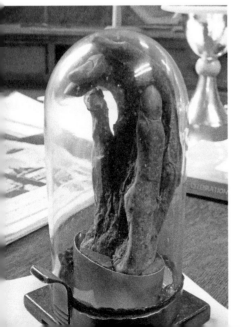

Father Arrowsmith's hand.

The Demon of the Oak

Many years ago, a young man named Edgar Astley came to Hoghton Tower dressed in mourning. He was mourning the loss of a young maiden who had died shortly after her marriage to his rival. One night some servants noticed lights burning in his room, and they were still lit the following morning. Although members of the family weren't perturbed by the nightly habits of their young visitor, there was much speculation as to the reasoning behind the nightly vigils.

It was agreed that one of the domestics should wait outside of the visitor's chamber and try to determine why it was necessary to keep a candle lit all night.

Hoghton Tower. *Inset*: Hoghton Tower, *c*. 1860.

When the hour approached, the servant stopped in front of Edgar's bedchamber and found that he could espy the goings on in the chamber through a gap in the solid door. He saw that Edgar was seated at his table and was focused on reading a large black tome. Then, Edgar placed a pinch of a brightly coloured powder into the flame, resulting in a foul-smelling odour being given off and the flame burning with increased brightness. After that Edgar muttered, 'Strange that I cannot yet work the spell. All things named here have I sought for and found, even blood of bat, dead man's hand, venom of viper, root of gallows mandrake, and flesh of an unbaptized and strangled babe. Am I, then, not to succeed until I try the charm of charms at the risk of life itself? And yet,' said he, 'so far have I gone uninjured, and now will I proceed to the triumphant or the bitter end'.

Next, the servant heard a voice posing a direct question: 'And wouldst thou not even yet give thy soul in exchange for speech with thy once betrothed?' Edgar stood and cried, 'Let me not be deceived! Whatever thou art, if thou canst bring her to me my soul shall be thine now and forever!' There was then a period of quiet before the sound of the dismembered voice could be heard again: 'Be beneath the oak at midnight and she shall be brought to thee. Darest thou first behold me?' 'I have no fear,' said Edgar.

As evening drew nigh the following day, only Edgar and one other in the household were still awake. Edgar was sat in his bedchamber and at an appointed hour he declared, 'The time draws nigh, and once more we shall meet.' He then collected all his bits and pieces and ventured outside, whereupon he was joined by a servant. They eventually reached the oak tree and Edgar placed all his materials at its base. Next, he described a large circle on the ground around himself and his companion, and placed a small cauldron on the grass and filled it with a red powder. When the flame was lit, Edgar struck the ground with his branch of hazel and repeated an incantation, whereupon the shadowy figure of a young child appeared for a short while. The servant then heard Edgar reciting more incantations, which was followed by terrible claps of thunder and lightning flashing round the tree. Edgar calmly went on with his incantation. As he was finishing the storm abated and silence followed, but then voices could be heard asking, 'Art thou prepared to behold the dead?' Without any hesitation whatsoever, Edgar replied, 'I am'. At that moment a heavy mist thickened in front of him, and in its centre Edgar beheld the beautiful, but sad, face of his betrothed. He stretched out his hand as if to fold her to himself, but the spectre vanished as the storm began to rage once more. Above all this noise it was clear that the Devil was still present. At that point the baronet came out and confronted him with the words 'in nomine Patris', and suddenly stillness fell. After such an experience Edgar was led away, never to regain his true sanity.

Location: PR5 0SH

Above: Outer courtyard of Hoghton Tower.

Below: Grounds of Hoghton Tower.

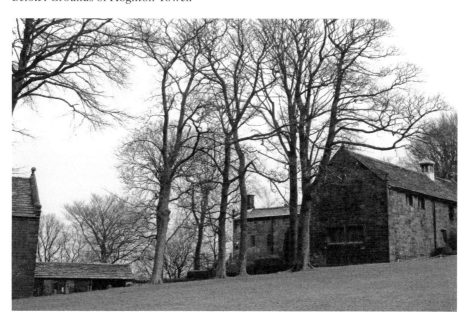

The Chivalrous Devil

Many years ago there lived a poor, deranged young man called Gregory, in a little village just outside of Garstang. Although he was always kind and thoughtful to the young people in the village many reviled him and treated him with loathing, but it wasn't really the children's fault as they were only following the example set by their parents. When Gregory walked along the main street there would always be heads popping out of the blacksmith's or cobbler's shop hurling abuse at him.

Gregory's mother loved her poor son with a tenderness as only a mother can. She lavished all of her love on him, and would not give the time of day to those who mocked and abused him. Many of her neighbours were very jealous of her as she had a very neat and tidy cottage.

One night, a number of the village boys decided to play a joke on the simple man. They agreed that one of them should dress up covered in a white sheet to scare him. A few nights later, when Gregory stepped out into the lane, the would-be jokers hid in a ditch and the 'ghost' hid himself behind a large oak tree. Not suspecting anything untoward, Gregory went singing on his way, but as he neared the tree a groaning white figure emerged from behind. The assailants had expected the poor young man to flee in terror, but his reaction was very different. He burst out laughing and was heard to exclaim, 'Oh, oh! A black one! A black one!' And sure enough, there was a huge dark figure stood right in the road. The would-be tormentors fled, with the black apparition closely behind them;

Below left: Garstang town centre.

Below right: Garstang Town Hall.

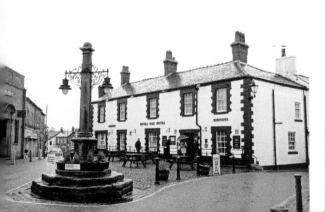

following him was Gregory, crying at the top of his voice, 'Run, black devil! Catch white devil!' Before long they reached the village, where a few of them darted into the blacksmith's shop while others took refuge in the village inn, but the mock ghost kept running, as if in a trance. When they reached the far side of the village the phantom disappeared as quickly as it had appeared and Gregory, unknown to the ghost, took his place. The would-be assailant then turned down a narrow side lane, but Gregory kept in pursuit, gradually closing the gap between himself and the white-clad figure. When Gregory caught him, he seized him and they fell into a ditch. Gregory was soon back on his feet and shouting as loud as he could, 'Catch, white devil! Catch white devil!' During this time, the ghost lay still in the ditch.

When the people in the inn were told the story they immediately ran out and made their way to the lane, only to find an agitated Gregory and the would-be white ghost lying motionless in the ditch. He was carried back to the village, where he lay at death's door for some weeks. Because the would-be ghost's parents were very poor, Gregory's mother volunteered to provide all of the medication that was required to aid his recovery. During that time, many people in the village warmed to her and treated her more affably. Gregory, too, formed a bond with the would-be ghost and they became firm friends.

Whenever any of the children in the village were tempted to taunt Gregory, they were gently reminded of the time when the Evil One himself came to Gregory's aid.

Location: PR3 1YG

Below left: Lane leading out of Garstang.

Below right: Outskirts of Garstang.

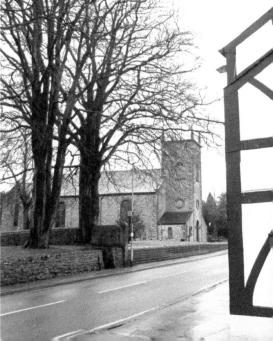

Furness Abbey

In 1124 monks from Savigny departed their monastery and established a temporary dwelling at Tulketh, on the banks of the River Ribble. The monks had been gifted Wagneia (Walney), the forest of Fuderness (Furness) and the fishery at Lancaster by Stephen, Count of Boulogne, for the express purpose of establishing and endowing an abbey of the Savignian Order. Building work on the abbey commenced July 1127, and sometime later the monks moved from Tulketh to the new abbey buildings. As the work of the order developed, men were drawn to their cause, including a young man called Wimund. Like many of the other monks at the abbey, Wimund was of humble birth, but he had a degree of education, possessing the skills to both read and write – a source of great power in the twelfth century.

During the following years the monks of the abbey gained a reputation for sanctity, which had the effect of increasing the abbey's power in the region. Indeed, their powers became so great that they began to establish branches of the monastery in Yorkshire and Lincolnshire. As early as 1134, King Olaf of the Isle of Man made a gift of land to the Abbey of St Mary in Furness for the foundation

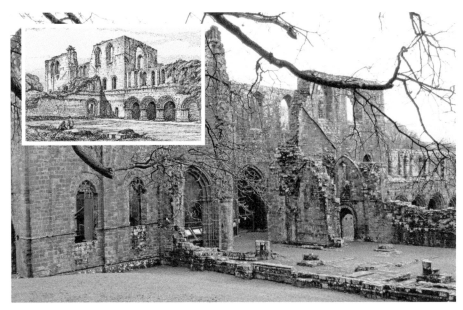

Furness Abbey. *Inset*: Sketch of Furness Abbey.

of a daughter house on the island, Rushen Abbey. Together with the lands to build the abbey, King Olaf endowed the mother abbey with the right to elect the new bishop of Sodor and Man from among their number.

Wimund was one of the monks chosen to help in the setting up of the new community in the Isle of Man. Because of his immense height and power of oratory, he soon ingratiated himself to many people in the island. Wimund was made bishop, but his election as was not a popular choice with everyone. Furthermore, following this he became more ambitious in the pursuit of power. He went on to persuade many of his supporters that he was the rightful heir to the earldom of Mowbray, but that he had been deprived his inheritance by the King of Scotland. In an attempt to regain his birthright he then engaged on a crusade against the king and, with his supporters, set sail for Scotland. He was successful in battle, but was confronted by another bishop who caused him some injury. He was forced to go into hiding for a time, before inflicting more terror on the Scots. Ultimately, King David granted Wimund land in the Furness region.

Wimund returned to the Furness and, in a demonstration of power, proudly told of his conquests and their reward. However, many people in the region remembered him as a God-fearing monk, and determined to make him pay for his arrogance. He was captured and bound hand and foot. His eyes were then gouged out and he was castrated, thus depriving him of sight and the ability to breed. He spent the remainder of his days at Byland Abbey in Yorkshire, but he never repented for his infamous actions.

Location: LA13 0PJ

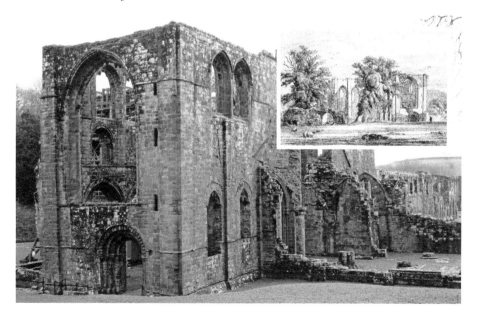

Furness Abbey's ruins. *Inset*: Furness Abbey, *c.* 1800.

The Headless Woman

Gabriel Fisher said his farewells to the merrymakers who were still enjoying themselves in the White Bull at Longridge and set off along the road with his dog, Trotty. Striding out, Gabriel walked towards Tootal Height and Thornley. There was a full moon that frosty night so his path was clear, apart from when a cloud passed in front of the moon. Without taking any time to rest, Gabriel continued on his way, heading towards the fells. When he reached the highest point in his walk he looked over Chipping's valley, majestic even in this light. All of a sudden a strange mood took hold of Gabriel and he wished that he had some company other than Trotty. He couldn't explain the feeling, but lots of thoughts flooded into his fertile mind and he remembered that only a few days ago he had seen a solitary magpie – always a bad sign. He dearly wished that Kemple End was not quite so far off.

Just as he was reflecting, he heard a shrill cry; followed by another. But, as the cries were not repeated again, he continued on his way. Looking down at the plantation below him, he thought that he'd seen something moving. He took a minute to steady his nerves before continuing to walk towards the source of his discomfort. Talking to his dog, he strived to reassure himself: 'It's only a woman. She's probably going to help someone at this hour.' As they were getting closer there was a wild, ear-piercing screech, causing Trotty to race off down the hillside. Undeterred, Gabriel continued on his way until he was almost upon the woman, who was dressed in a long cloak and hood and wore a large coal scuttle bonnet. When he was almost next to her he called out, 'It's a lovely night, but isn't it a bit late for you to be out?' The woman replied, 'Yes, it's a very fine crisp night.' Gabriel asked if there was anything he could do to help, but the woman

The White Bull.

didn't answer. Gabriel tried to fathom why a woman would be out at this time of night. It was clear that she came from a different class from him, but why was she dressed in such ordinary working-class clothes?

Gabriel offered to carry her basket, but as she handed it over a voice seemingly coming from beneath the white cloth that covered the basket said, 'You're very kind I'm sure.' Gabriel dropped the basket, exclaiming, 'What can this be?' His question was answered when the cloth slipped off and a human head came tumbling out. 'It's the headless boggart!' Gabriel cried. He fled down the hill but before he had managed to get very far away, he heard the clatter of feet directly behind him. He ran even faster, until he reached the apparent security of the old Chaigley Road, but as he was turning into it the head itself, thrown by the boggart, went whistling past him. Gabriel now had the headless woman directly behind him and the head in front of him. Fortunately, Gabriel still had plenty of energy left and ran on until the clattering of the woman's feet and the bumping of the head were well behind him. It was only when he leapt across the stream near to his home that the spine-chilling sounds stopped.

Gabriel's wife found it difficult to accept that an ordinary woman – with a head on her shoulders – couldn't stop him from coming home late at night, but a headless woman could.

Location: PR3 3BJ

Above left: The Headless Woman.

Above right: Lane leading from the White Bull.

The Christmas Eve Vigil

Many years ago in Walton-le-Dale there lived a particularly reserved clergyman. There was concern as to the amount of time that he devoted to the mysterious-looking volumes that he possessed. Suspicions grew as his housekeeper reported that a number of strange-looking bottles had been delivered. If the clergyman had paid more attention to the rumours that were circulating, he would have understood why parishioners averted their gaze when acknowledging his greetings.

It came as something of a surprise to the congregation when the clergyman formed a friendship with one of the older members of the village, who also partook in some strange pastimes. Owd Abrum, as he was known, had an encyclopaedic knowledge of the medicinal benefits of herbs, and he also had books on subjects ranging from botany to astrology. But there was a mystique around this man; many villagers thought that he had the power to cast trouble upon them if they failed to show him respect.

Owd Abrum, or Abraham, could always be seen collecting his herbs – be it early in the morning or last thing at night. One night, when the clergyman was returning from a walk, he thought that he heard a voice and realised that it was the herbalist. They talked about the plants that the old man had been gathering, and the clergyman was astonished by the wealth of knowledge that the old man possessed. After some further discussion they retired to the old man's cottage.

St Leonard's Church.

Right: St Leonard's Courtyard.

Below: St Leonard's Graveyard.

Indeed, they became so engrossed in their conversation that it was not until first light that the clergyman departed Abraham's cottage. From that moment they became firm friends, meeting almost every day to exchange information and share knowledge.

One time, as they were walking through God's Acre, the clergyman mentioned that it was his understanding that if anyone performed a particular ceremony in the church porch on Christmas Eve the visage of anyone who was going to die in the coming year would be revealed. Before parting they agreed to keep the vigil.

It was snowing when they set forth on their way to the church carrying St John's wort, mountain ash, bay leaves, and holly. They deposited a can of burning charcoal upon a tombstone, but then they heard the ringers on their way to the belfry. After they'd passed, they entered the porch and made a circle of vervain, bay, and holly around themselves. They each held a branch of wiggin and powder was scattered upon the embers of the fire. The atmosphere changed as they chanted a Latin prayer and they soon heard the strains of sweet music. On hearing this, the men sank to their knees and the temperature suddenly dropped. They then saw a group of people wending their way towards the porch, dressed in grave clothes. As they came closer, Abraham recognised one of the mourners: it was the man kneeling by his side! The clergyman fainted after seeing the apparition too. When he regained consciousness he was too weak to walk, so Abraham asked the ringers for help.

The story soon became known in the village. Whenever anyone fell ill, relatives invariably asked if they would survive. The clergyman went on holiday, but was killed in a tragic accident.

Location: PR5 4HJ

Fields around St Leonard's.

All Hallows' Eve

Many years ago, standing at the foot of Pendle, there was a farmer who lived with his family and the one labourer that he employed. Although he believed in witches, the farmer had no personal experience himself. That was all to change after a very wild night. The following morning the farmer found three beasts dead in the shippon, the crops in the fields became blighted and two of his children fell ill. He finally admitted to himself that he had incurred the displeasure of some unknown forces and that all the measures he'd taken to keep dark forces away had lost their power of protection. In his torment, the farmer decided to meet with the witches and his trusted labourer, Isaac, volunteered to accompany him. His wife remonstrated with him, suggesting that he should abandon this ill-conceived notion. But the farmer was adamant, saying that others had met with the witches and had been given immunity from any misfortune.

One day, after their work had finished, the farmer and Isaac sat and waited for the time when they would venture to Malkin Tower to encounter the witches. Neither was looking forward to the evening's work, but it was necessary for their continued well-being. As they departed for the tower, both carried a branch of mountain ash that had several sprigs of bay tied to it to ward off any lurking fiends. In the other hand they carried an unlit candle and the farmer's old bulldog also accompanied them.

On reaching the foot of Pendle they lit their candles, but became engulfed in a sudden and ominous dark silence. 'Well, I think that it's nothing but a storm,' said the old labourer, as he turned and began to climb the hill with his master and dog closely behind him. Just as they were nearing the top of a steep ravine a flash of lightning pierced the darkness, lighting up the whole of the sky and shaking the earth beneath their feet. Seconds later, there was an ear-piercing shriek of laughter as a black figure went gliding slowly past them. The dog immediately turned and darted away down the hillside, but the two men continued to climb. Isaac stumbled and almost fell, but the farmer exhorted him to be more careful. The pair eventually managed to get within sight of the tower without further mishap.

It was clear that there was something going on as they could hear shrieks of laughter and saw dark figures floating over their heads. They were inclined to turn back, but as soon as they turned they saw a satanic face and the lights in the tower went out. The men became terrified beyond measure and ran as hard as

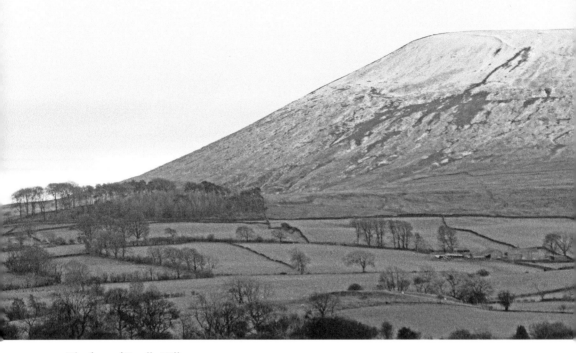

The foot of Pendle Hill.

they could, heading in what they thought was the general direction of the farm. In his haste, the farmer (who had taken the lead over his aged companion) fell and completely vanished. He had slipped down the cleft where Isaac now stood.

After searching for some considerable time and receiving no response, Isaac turned and made for the farm in the hope of gaining assistance in his rescue attempt. But, being afraid of the thunder and lightning crashing around him, he took refuge under a large bolder and waited for the morning. He was awoken by the old bulldog licking his face, and he could see a number of men in the vicinity.

Startled by the earlier arrival of the dog, the farmer's wife sensed that there was something wrong and trudged all the way to a neighbouring farm to seek help. After finding Isaac, it was but a short while before they found the farmer at the bottom of the gorge, nursing nothing more than a broken leg.

Location: BB9 6RQ

The Chylde of Hale

In 1578, John Middleton (known locally as the 'Chylde of Hale') was born in the village of Hale, which was in the parish of Childwall and under the jurisdiction of the see of Chester. He was buried in the village churchyard in 1623 and his gravestone bears the following inscription: 'Here lyeth the bodye of John Middleton, the Chylde of Hale. Born ad 1578. Dyed ad 1623.'

Middleton's claim to fame is that he was reputed to stand 9 feet and 3 inches tall. His hand alone measured 17 inches from the carpus to the end of the middle finger, and the breadth of his palm was 8 inches and a half. Because of his size, Sir Gilbert Ireland, Sheriff of Lancashire, hired him as a bodyguard. In 1620, Middleton was taken to the court at the direct invitation of James I, where he is said to have been regaled 'with large ruffs about his neck and hands; a striped doublet of crimson and white round his waist; a blue girdle embroidered with gold; large white plush breeches powdered with blue flowers; green stockings; broad shoes of a light colour, having red heels, and tied with large bows of red ribbon; just below his knees bandages of the same colour, with large bows; by his side a sword, suspended by a broad belt over his shoulder, and embroidered, as his girdle, with blue and gold, with the addition of gold fringe upon the edge'. While at court it is said that he pitted against the king's wrestler, who he overcame and inflicted a degree of injury, causing some disquiet among the courtiers. Middleton was immediately dismissed from court with a purse of £20 – a significant sum at the time. On the way back to Hale, Sir Gilbert stopped off at Brazenose College, Oxford (his former college), where, so taken by Middleton, a life-sized portrait of

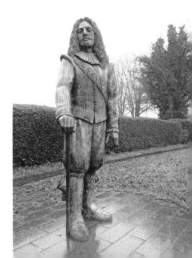

Statue of the Chylde of Hale.

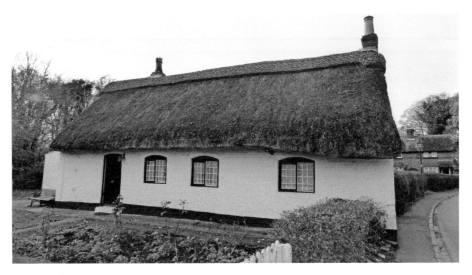

Chylde of Hale's cottage.

him was painted. Unfortunately, when continuing on their journey, they were set upon by robbers and his purse of £20 was stolen. John Middleton died in poverty.

Many years after his death, Middleton's body was taken up and his principal bones were preserved at Hale Hall, where they were subjected to further examination. It was recorded that Middleton's thigh bone, when measured against a normal-sized man, reached from his hip to his feet. All of the other measurements that were taken were found to be of a similar proportion. It is thought that when Middleton grew to his great height – reputedly overnight – he could only stand upright in the centre of his cottage, and therefore had to resort to sleeping with his legs hanging out of the open window.

On one occasion, Middleton was said to have fallen asleep near to the banks of the Mersey, only to find a massive bull stood some way in front of him when he woke up. The bull went to charge, but because of Middleton's immense strength he caught the animal by the horns and threw him over to the next field. Middleton was able to walk home without any further hindrance.

Another legend that lives on in Hale relates to the time when Middleton was suffering from an unknown illness. During the period of the illness he was imbued with immense strength, so much so that one of his closest friends was forced to chain him to his bed so that he would not cause any damage in his delirium. Upon his recovery two of the chains were given away. One of the chains was sent to Boston in order to prevent the Stump from being blown into the sea, and the second chain was despatched to Chester so that the Dee Mills could be saved from floating down the river. There was a third chain, which, it was said, helped to restrain the king when he was suffering from a particularly troublesome complaint.

Location: L24 4AX

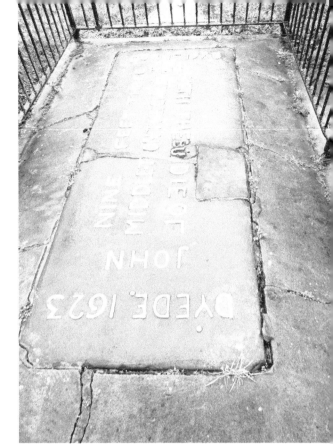

Right: Grave of Chylde of Hale.

Below: Chylde of Hale pub.

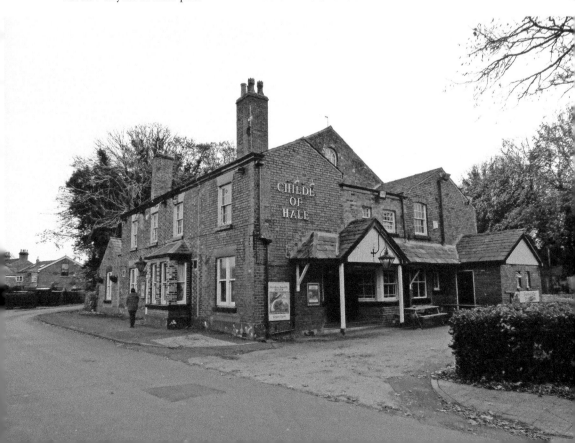

The Unbidden Guest

Many years ago in a lane near to the centre of Clitheroe there lived a famous wizard. He could see the future and many paid him to tell their fortune. The cottage where Jeremy lived was very modest; the inside walls were covered with moth-eaten black cloth. The only light in the room came from a candle that dangled over the table. Jeremy himself sat in an old-fashioned chair and 'held court'. He was a strange-looking man with long, bony fingers and a shaggy white beard. And, although he invoked satanic powers for his many visitors, he did not believe in them himself.

One day he pulled aside the curtain to reveal the sunlight streaming through the window. He exclaimed, 'Tis a bonnie world, and there are few views in it to compare with this one for beauty. It will always be there, even after us mortals have come and gone.' Following this observation, Jeremy sighed and turned away from the window, only to find that he was no longer alone. There was a strange-looking visitor sat in the chair normally occupied by paying visitors. Jeremy asked what the visitor wanted, only to be told that as he had collected fees from unsuspecting innocents, it was his turn to take his percentage. Jeremy replied, saying, 'Even if you had a claim to any reward, it wouldn't need a packhorse to carry your share away.' The stranger laughed at this last remark and replied that he would not be denied. Following this exchange, everything went dark and even the view outside looked forbidding, with frequent flashes of lightening.

Lane at centre of Clitheroe.

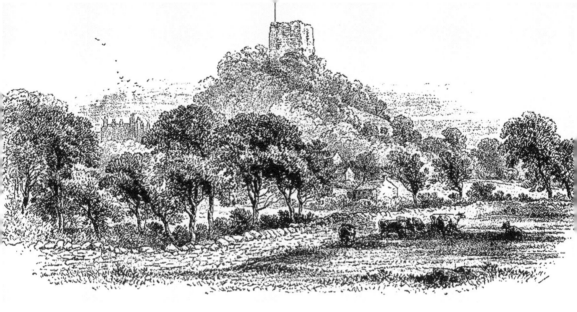

Above: Clitheroe Castle, *c.* 1850.

Below: Clitheroe Castle.

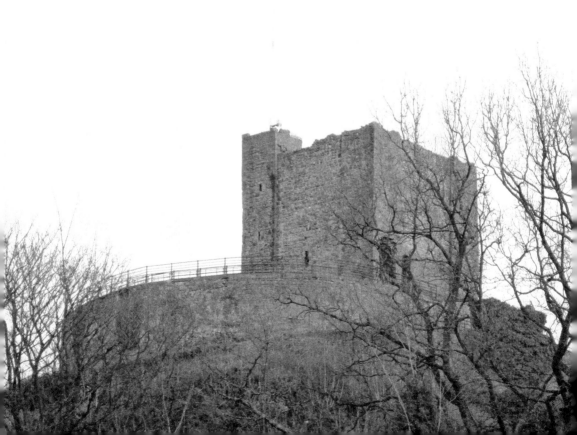

Totally exasperated, Jeremy opened the door and bade his unwelcome visitor depart forthwith, but then Jeremy observed the stranger's cloven foot and realisation dawned. Acknowledging Jeremy's recognition, the unbidden guest gave a blood-curdling laugh. The visitor then produced a parchment and suggested that Jeremy should append his name to it, saying that if he signed then for the next twenty-two years he would have untold riches, but Jeremy refused. Without further ado, the visitor departed.

After a very quiet week, Jeremy walked to the village to purchase some vitals. Normally children avoided any contact with him, but today they kept on playing their games and villagers acknowledged him with friendly greetings. He was told in the village of a newcomer who possessed magical powers. He realised that he'd made a terrible mistake and wished that he could have another chance. No sooner had he had this thought than there was a clap of thunder and his unbidden guest was once again sat in the chair, with the document on the table. The Devil asked if Jeremy was ready to sign. This time he answered in the affirmative, but said that he couldn't write. On hearing this, the Devil seized Jeremy's hand and, using it as a pen, scratched out 'Jeremiah Parsons, his x mark'. He then departed. Shortly after, a man knocked on the door asking for a consultation, during which time he commented that the wizard who lived in Clitheroe had left. Over the following years Jeremy acquired untold wealth, but then the end came. Jeremy's house was razed to the ground and, even though they searched, nobody could find any trace of him.

Location: BB7 2DD

The Ribble at Clitheroe.

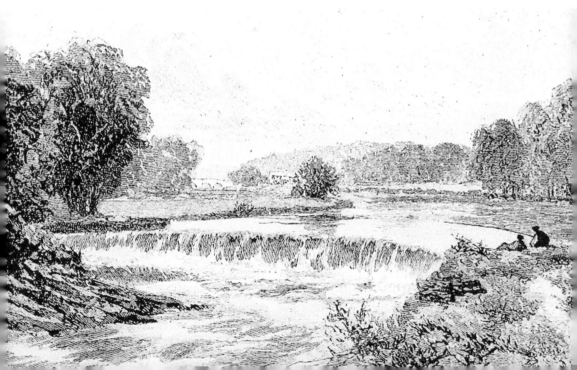

Bearnshaw Tower and
Lady Sybil

Bearnshaw Tower was a small fortified house built in one of the ravines branching off from the great gorge of Cliviger, around 5 miles from Burnley. The original foundations of the house can still be seen near to the Eagle's Crag. The owner of the house was an heiress, celebrated both for her wealth and stunning beauty. She could often be seen at Eagle's Crag studying nature and generally admiring the surrounding countryside. It was during her visits to the area that she dearly wished to possess supernatural powers, so that she could join in the nightly rituals and practices with the Lancashire witches. Then, almost without thinking, she

Bearnshaw Tower.

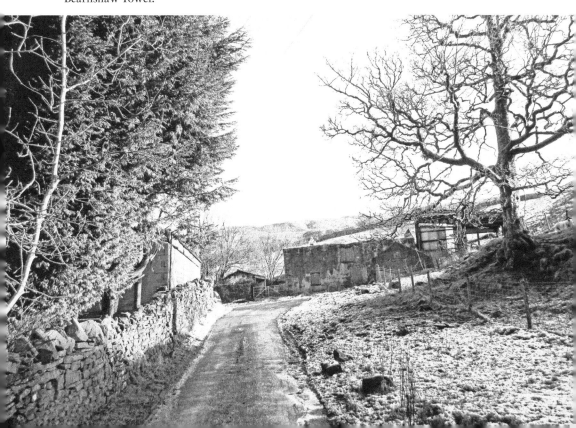

was persuaded to sell her soul to the Devil in order to fulfil her dream. The bond was duly sealed with her blood, and she entered into a completely different world.

At that time Lord William, who resided in the nearby Hapton Tower, wished for the hand of Lady Sybil of Bearnshaw Tower, but his proposals were never successful. In desperation he resorted to securing the powers of one of the most famous of the Lancashire witches, Mother Helston. Following many spells and incantations, she declared that he would meet with success on the next All Hallows' Eve. On the day specified Lord William went out hunting, according to the witch's directions. It was as he approached Eagle's Crag that he spotted a milk-white doe and his dogs immediately gave chase. They covered many miles in the immediate vicinity until, exhausted, they returned to the crag. It was upon their return that Lord William noticed they'd been joined by a strange hound, but it was one that he knew very well; it was the familiar of Mother Helston. The hound had been sent to capture Lady Sybil, who was disguised as the white doe. In hot pursuit of the doe, Lord William's horse missed its footing and almost threw him into the abyss. Then, just as the doe was heading towards safety, the strange hound seized the doe by the throat, holding her fast. Lord William then took charge of the situation, securing a silken leash around the doe's neck. He then, triumphantly, led her back to Hapton Tower. But all was not well. During a particularly stormy night, Hapton Tower was shaken by an earthquake. In the morning, the heiress of Bearnshaw Tower had taken the place of the captured doe.

Over the coming weeks there was much frenzied activity. Lady Sybil's powers of witchcraft were suspended, and in the fullness of time Lord William married his bride. But, less than a year later, Lady Sybil had reverted to her former debauched practices. On this occasion she had been transformed into a beautiful white cat and was enjoying activities in Cliviger Mill. The miller Giles Robinson had sent his manservant Robin to watch over the mill during the hours of darkness. Upon seeing the cat, Robin had promptly cut off one of its paws.

The very next morning Lady Sybil lay in bed, very poorly. Later in the day, Robin appeared at the tower carrying the lady's hand. The mystery of her sudden indisposition was soon answered. Lord William was furious when he realised just what had been happening, but taking a pragmatic approach he once again enlisted outside assistance and Lady Sybil's hand was rejoined to her arm. There remained, however, a deep red ring around her wrist where Robin's sharp knife had caused the severance.

Over time they reconciled, but Lady Sybil's health was now beginning to decline and she was soon nearing death. Seeking clerical assistance, Lord William was able to cancel the Devil's bond before she died. Lady Sybil died in peace, but Bearnshaw Tower has remained deserted ever since.

Locally, it is still said that on All Hallows' Eve the hound and the milk-white doe can be seen on Eagle Crag.

Location: OL14 8QA

Above left: Lane leading to Bearnshaw Tower.

Above right: Lady Sybil at the Eagles Crag.

Below: Descent into Cliviger.

The Crier of Claife

A long time ago, the Windermere ferryman was awoken by a terrible shriek. The ferryman and his family thought that it was nothing more than the cries of the storm, but then there was another, which prompted the ferryman to unfasten his boat and cross the lake, even though his wife and daughter implored him not to venture out.

After being away for some time they saw the boat emerge from the darkness of the lake, but fearing that something untoward had happened they rushed to the water's edge, where they saw the ferryman speechless and obviously terrified out of his wits. They led him to the cottage, but he couldn't be persuaded to tell what terrible sight he had seen. His health deteriorated until he eventually died, never having revealed what he had witnessed on that fateful night. After the funeral there were too many memories for the women to remain, so they left and went to live in Hawkshead. Two men and their families took over the ferry, but on the first night that they were there they too heard the fearful cries coming from across the lake. They were terrified!

The Ferry House.

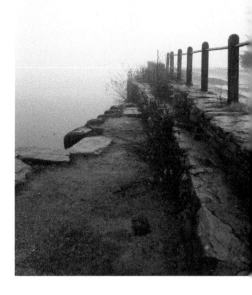

Lane to Ferry.

As the story spread, travellers stopped using the ferry during twilight hours, preferring to travel during daylight. The ferrymen soon realised that unless they got rid of the unseen being, their business would be doomed. They decided to seek the assistance of the monks at Furness. Upon arrival they were ushered into the presence of the abbot, who readily agreed to help on the proviso that if the monk he sent was successful then the abbey coffers would not be forgotten.

They were soon on their way back, taking one of the monks along with them. The first night back nothing of any significance happened. On the second night a storm was brewing, although no cries were heard by the intrepid dwellers. The monk was beginning to think that the whole event was nothing more than an elaborate ruse. Then, just before midnight, he jumped out of his chair having heard the dreaded cry. He summoned the men to take him to the centre of the lake. They were hoping that he would go alone but they remembered that he was there at their behest. When they were about halfway across the lake they heard a terrible scream, which appeared to come from very near to the boat itself. One of the ferrymen immediately fainted, while the other man and the monk stared, petrified, at the scene ahead of them. They then found a fourth person in the boat: a ghastly figure with shrunken limbs and a gaping wound at his throat.

The monk recited a prayer for protection, sprinkled holy water on the three of them and then read aloud a short service of exorcism, whereupon the ghastly figure vanished. The monk was taken to the shore and before leaving said that should the spirit ever return, then it would be confined to a disused quarry some distance from the ferry cottage.

Many people in the area still believe that the crier can be heard over the lake on stormy nights.

Location: LA12 8AS

Above: Island in Lake Windermere.

Left: Mist over Lake Windermere.

The Clegg Hall Tragedy

Clegg Hall stands around 2 miles north-east of Rochdale. The original building was built by Bemulf de Clegg and his wife Quenilda during the reign of Stephen.

In 1241, Baron de Clegg set off for Poitou at the behest of his king, Henry III. He trusted the care of his two beloved sons, Bertrand and Randulph, to his brother Richard, imploring him to watch over them during his absence. Richard assured him that he would care for the young boys until his return. However, no sooner had the knight's ship departed than his evil brother set about devising a strategy whereby he could gain the de Clegg family fortune for himself.

Bertrand, who was fourteen, looked up to his uncle as a hero, but Randulph (younger by a year) had a deep-seated mistrust of his guardian and watched his every movement like a hawk. One night Bertrand wandered some distance away from his home. When he returned, the sentry on duty admitted him without

Clegg Hall.

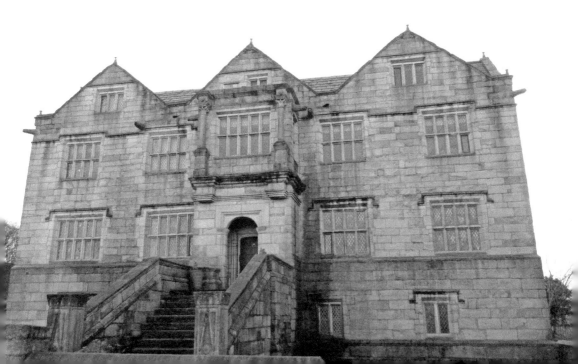

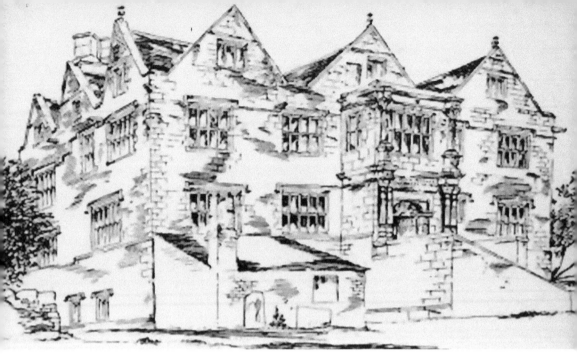

Clegg Hall, *c.* 1845.

question and then returned to his rest. What the sentry failed to observe was the tall, dark figure following the young boy. He also failed to observe a second young boy following at some distance. Richard de Clegg thought he had been handed a golden opportunity to rid himself of one of his obstacles to the family fortune: Bertrand. Only the sentry knew of his return – and he could be bribed – so the boy could be hurled into the moat and nobody would know how he got there. Richard hid himself, ready to kill the young heir, but just as he was about to pounce on him a voice rang out: 'Brother, beware!' Thus warned, Bertrand drew his dagger and stood guard. Richard instinctively knew where the warning had come from and immediately ran over and gripped Randulph's throat. Seeing exactly what was happening, Bertrand then ran forward, just in time to see his uncle throwing Randulph into the moat below. Bertrand leapt upon the foul assassin and dealt him a heavy blow with his dagger, but the older man was too wily for him and gained the upper hand. It wasn't long before the brave Bertrand had been disposed of in the same way as his brother.

The English army was ultimately defeated and Baron de Clegg returned to his home longing to see his two sons, only to be greeted by news of the tragedy. He vowed to avenge the death of his beloved children. What he couldn't understand was why his brother had allowed the boys to wander so far away and, in a fit of anger, he banished him from the hall.

The disgraced Richard sought the refuge of his friend Hubert de Stubbeley, offering to reward him well for any assistance. After much bartering, de Stubbeley showed him a secret passage that ran between Stubbeley and Clegg Hall, the exit of which was directly behind the tapestry in the baron's bedchamber.

Above left: Canal at Clegg Hall.

Above right: Weavers' cottages near to Clegg Hall.

De Stubbeley then prompted Richard to kill his brother and return to Stubbeley – nobody would be any the wiser.

Unsettled from the news of his sons' demise, when the baron did eventually find sleep he was awakened by a voice crying, 'Father, beware!' He jumped up and saw his younger son pointing to his brother Richard, who was standing near to the tapestry with a dagger in his raised hand. In desperation Richard, in vain, tried to find the entrance to the secret passage. His only recourse was to run out of the bedchamber and try to make good his escape. It was a forlorn attempt and he leapt to his death in the icy waters of the moat below.

Whenever danger looms, a voice can still be heard crying, 'Father, beware!'

Location: OL15 0AF

Cartmel Priory

There are historical records relating to Cartmel some 500 years before Cartmel Priory was built. It is thought that in or around 680 King Egfrith of Northumbria gifted the village to St Cuthbert.

The priory itself was founded in 1189 by William Marshal and was intended for a community of canons regular of Saint Augustine. The priory was dedicated to Saint Mary the Virgin and Saint Michael. William also granted the twelve canons, who had been sent from Bradenstoke Priory in Wiltshire, the whole fief of the district of Cartmel.

When the monks travelled to Cartmel to found the priory they selected the top of hill, which had commanding views of the surrounding countryside. Then, kneeling to pray, the prior became aware of somebody nearby. He looked up and saw a man dressed in green in front of him. 'This is not the place you seek,' said the man. 'And how do you know what I seek?' replied the prior. The man explained that the site he had chosen was a place of worship for those who followed the old religion, and that he and his monks should build their church on land that lay between two rivers flowing in opposite directions. The prior realised he had never heard of two rivers flowing in opposite directions, but when he turned to make this point the little man had vanished. He began to question exactly what he had witnessed, then turned and went back to inform his brethren. Although surprised at what the prior had to say the brothers thought his advice couldn't be ignored, so they trusted in God to lead them to a suitable place that they could build their church.

A mere few days later, one of the novices came running to the prior and asked him to accompany him to a fast-flowing stream. The young monk tossed a twig into the water, which rapidly made its way towards Morecambe Bay. Next, the young monk directed the prior to another river, just half a mile away from the first one. Amazingly, when the monk threw a twig into this river, instead of flowing towards Morecambe Bay, the twig started to float in the direction of Lake Windermere. The monks built their priory on a small island of hard ground in a valley, surrounded by marshy ground and close by a ford, which was the only crossing point for the River Eea.

In a gesture to acknowledge the help of the green man, his likeness is carved on a misericord in the choir stalls.

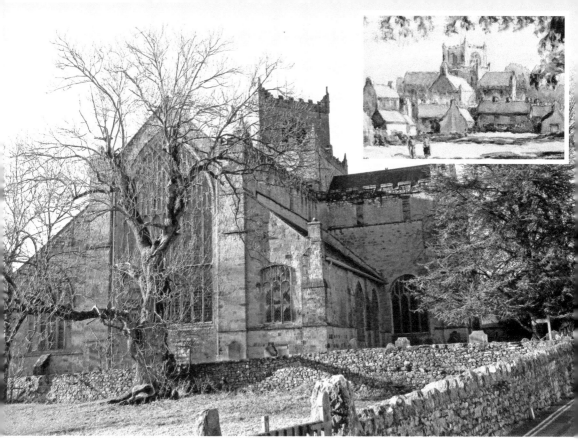

Cartmel Priory. *Inset*: Cartmel Priory, *c.* 1830.

When William Marshal founded the priory, it was stated in the deeds that the church was also to be used by locals as their parish church, but during the time of the Dissolution of the Monasteries the monks were expelled and all of the church's assets were taken, including the lead from the roof. There was much resistance from the monks and after a petition from villagers to save the priory, the church itself was spared; however, all of the other buildings were destroyed, with the exception of the gatehouse, which was then being used as a manorial court. The subprior, several of the monks and ten villagers were hanged at Lancaster on charges of treason.

Location: LA11 6QD

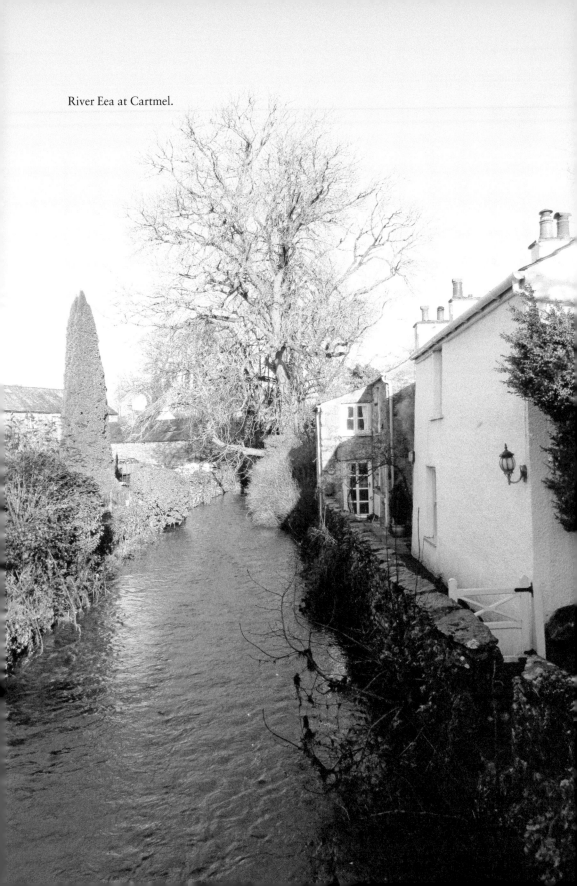

River Eea at Cartmel.

The Invisible Burden

The Wyresdale Arms was a popular watering hole in the Forest of Bowland – not far from Preston. All the farmers and cart drivers in the district patronised Nathan Peel's hostelry. One day, revellers in the snug urged an old chap to retell the story of 'th' quare weddin''.

Gazing, as though peering into the past, the old man spoke with a great deal of emphasis:

It must be over forty years now, and I was just a young man at the time. The wedding that I'm going to tell you about was between the eldest son of Mister Singleton of Dyke Farm and the prettiest lass in the county. Everyone made their way to the church to witness the wedding, but on the way back young Adam, the man in question, raced off like a man possessed. However, instead of going along the old road across the Stone Bridge, he charged off down Owd Horse Lane. Fortunately, the mare seemed to know what the young man was up to and entered into the spirit of the day. All the guests followed about a mile behind, with the milk cart leading the way. Everyone was laughing and enjoying the day's festivities. As it happens, the gate to Owd Horse Lane was wide open, much to the disappointment of everyone following the young couple, as they were hoping to gain a minute or two as Adam had to get down from his cart to open the heavy gate. Being open, the horse went charging through, carrying Adam and his wife on their merry way. About midway along the lane, the road dipped a little and water from the spring in the bank ran over, reaching about a foot or so up the wheels of the carriage. At that point the horse abruptly stopped, throwing Adam right out of his seat and into the hedgerow. Fortunately no bones were broken, so he climbed back into the carriage, ready to call for the mare to make another start. But, as much as Adam coaxed and chided the horse to start, she just wouldn't move an inch. A few minutes later some of the guests came upon the scene. They tried to move the carriage forward, but it seemed as heavy as a fully laden wood cart, even with eight or ten wedding guests slaving at the wheels and the horse straining as hard as possible. Nobody could understand what was happening. Just then the vicar arrived and he had a good look around, but he too couldn't find anything that might cause the problem, though said he'd often seen carts stuck there.

Some years later the vicar had his son Will with him and he asked to go via the lane. Against his better judgment, the vicar went that way and got stuck at the spot where everyone else did. He realised that it was no use using the whip, so he got down from the cart and then, all of a sudden, Will shouted that he could see 'the Old Lad' – a heavy, fat chap wearing a bright red cap and sitting on the back of the cart. Next, Will shouted, 'He's gone' and no sooner had those words been said than the horse started off at such a pace that had never been seen before. After that, no carts were ever stuck at the spot again, and nobody ever knew why.

Location: PR3 2NL

Farington Cotton Famine

At the beginning of the nineteenth century, the small village of Farington (near to Leyland) was very much a rural community and the population was small. Until, that is, in 1835 when the enterprising William Boardman built a cotton mill near to the proposed site of the railway station; the population doubled within the space of a decade. Being an enlightened employer, Boardman built cottages for his employees. They were well-maintained, receiving a new coat of paint every year. William Boardman also looked after the general well-being of his staff, organising evening classes and Sunday schools.

Because mills in Lancashire had to a large extent become dependent upon American cotton, the political climate there dictated that either cotton was imported in the knowledge that slave labour was being used, or they could stand together with President Lincoln, abhor slave labour and refuse to accept the imports. The latter choice was adopted, resulting in much hardship to the mill workers. But, when they were asked the direct question, 'Do we believe that people, whatever their colour, should be in chains?' they responded with a resounding 'No!'

Workers' cottages in Mill Lane, built in 1836.

Cottages in Mill
Lane today.

Then, as early as January 1862, many mills reduced the hours in the working week from six to four days, with the resultant proportionate loss in wages. In September of that year the mill in Farington completely ceased production, and workers found it increasingly difficult to live under such severe economic constraints. In addition to trying to live on any savings, many were forced to sell household furniture. As the situation continued to become worse, the 'Famine Song' could often be heard around the village:

> I'd work but cannot – starve I may.
> But will not beg for bread.
> God of the wretched hear my prayer
> I wish that I were dead.

Mill owners in the area often continued to pay employees a much-reduced wage even though they weren't working, and relief committees were established to help alleviate severe hardship. Some sewing work was found for women and young girls, whereas many of the village's men were found work maintaining the roads in the immediate area. Ultimately, some mill owners – including William Boardman – either reduced or completely cancelled any rent arrears on workers' cottages. And, in many cases, they also supplied fuel to workers.

This situation pertained for upwards of two years. Then on Wednesday 30 April 1864, it was rumoured that a consignment of cotton had arrived at Liverpool and was being transported to the mill. Two wagons of cotton arrived at the station the following day. The women of the village willingly pushed the wagons up the steep hill to the mill, singing and waving Union flags as they went. When the cotton reached its intended destination, the crowd – which had now swelled to several

Above: Farington Mill in full production.

Right: Railway line at Farington.

hundred – spontaneously sang the words of the modified 'Lancashire Doxology' to the tune of 'Old Hundredth':

Praise God from whom all blessings flow.
Praise him who sendeth joy and woe.
The Lord who takes, the Lord who gives,
O, praise him, all that dies, and lives.

He opens and he shuts his hand,
But why, we cannot understand;
Pours and dries up his mercies' flood,
And yet is still all-perfect Good.

We fathom not the mighty plan,
The mystery of God and man,
We women, when afflictions come,
We only suffer and are dumb.

And when, the tempest passing by,
He gleams out, sun-like, through our sky,
We look up, and through black clouds riven,
We recognise the smile of Heaven.

Ours is no wisdom of the wise.
We have no deep philosophies:
Childlike we take both kiss and rod,
For he who loveth knoweth God.

Location: PR25 4QR

Hornby Chapel and Sir Edward Stanley

Sir Edward Stanley, fifth son of Thomas, 1st Earl of Derby, received the favour of Henry VIII, who always greeted him in familiar terms: 'Ho! My soldier'. It is said that 'honour floated in his veins, and valour danced in his spirit'. He commanded the rear of the English army at Flodden, and it is said that it was through his bravery that the battle was won. He induced the Scots to descend from the hill they were holding, which caused their ranks to open, whereupon he launched a devastating attack with Lancashire bowmen. The unexpected attack caused disorder and chaos in the Scottish ranks, which in turn gave fresh hope to the English army. Following this comprehensive victory, Sir Edward received a letter of thanks from the king himself, assuring him of future reward.

At Whitsuntide the following year, when the king was at Eltham in Kent, he decreed that because the victory was worthy of his ancestors, who bore an eagle on their crest, he should be created Lord Monteagle. He was summoned to Parliament and created Baron Stanley, Lord Monteagle, during the same

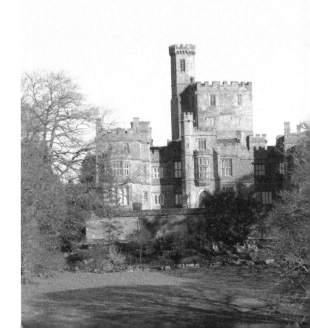

Hornby Castle.

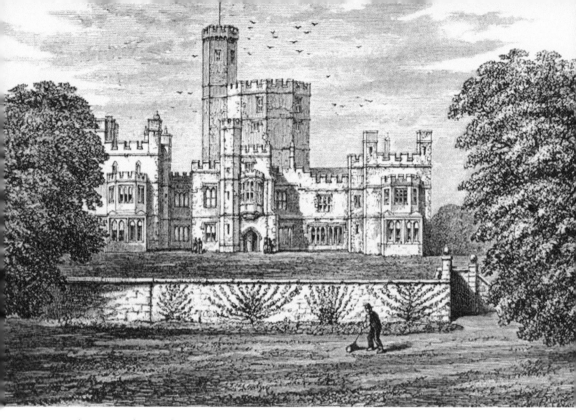

Above: Hornby Castle, *c.* 1830.

Below: Hornby Castle Lodge.

year. On many occasions after that he rendered great service to his country and was renowned for his bravery and his knowledge and understanding of combat strategy. He later married into the Harrington family and resided at Hornby Castle, looking after his own financial affairs.

By several nefarious means, especially during his later years, Stanley took charge of all of his wife's estates and also those of her uncle, Sir James Harrington. He was absolutely contemptuous of the affairs of the world around him and gave no weight to what others thought of him. Friends and enemies alike testified to the fact that he craved for enjoyment in his present life and had little or no fear of retribution in another. It was perhaps because of this that he was later accused of poisoning his brother-in-law, John Harrington. He was also suspected of perjury in order to prove himself tenant of Hornby. There is also an allegedly fictitious account relating to the imputed crimes of Lord Monteagle wherein, among other assertions, he questions the authenticity of the Christian religion with the rector of Slaidburn. However, it is believed that the rector was victorious in the ensuing discussion. The tale goes on to suggest that sometime after the discussion with the rector, Lord Monteagle saw an apparition of the murdered man in the form of misty white cloud. It is said that this single event changed both Lord Monteagle's fundamental beliefs and the manner in which he conducted his life. Lord Monteagle commissioned the building of the Chapel of Horny, which bears the legend '*Edwardus Stanley, Miles, Dns Monteagle, me fieri feciti*' (Edward Stanley, Knight, Lord Monteagle, caused me to be erected). He died espousing the faith he once despised.

Location: LA2 8JT

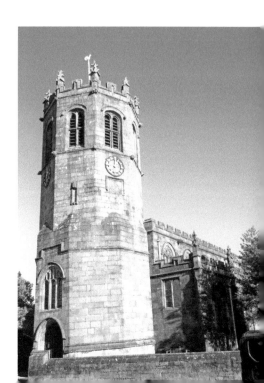

St Margaret's Church, Hornby.

The Pig of Winwick Church

The village of Winwick in the civil parish in Warrington is around 3 miles north of the town centre and located within the historic boundaries of Lancashire. The village borders Newton-le-Willows (formerly known as Newton-in-Makerfield) and Burtonwood. One of the very first buildings to be erected in the area of Winwick was the parish church – even before the village had been given a name. At that time the village was little more than a tiny hamlet with a small number of workmen's cottages.

Received wisdom would suggest that the Battle of Maserfield was fought at Oswestry on the Welsh borders on 5 August 642 (possibly 641) between King Oswald of Northumbria and King Penda of Mercia. King Oswald fell in battle, although some local historians contend that the place of his demise was Makerfield near Winwick, Lancashire, rather than Maserfield in Shropshire. Following the death of the king, travellers and pilgrims often left stones at the spot as a lasting tribute to his memory. It was decided that a bigger church should be built on the spot where the king fell, which would mark as a tangible tribute to St Oswald. Accordingly, stonemasons laid new foundations near to where the smaller church had stood. Indeed, they made particularly good progress on the first day of construction, but then something as remarkable as it was mysterious happened that night. As the sun was going down, a pig was seen removing stones from the building site, taking them in its mouth and running towards another site crying, 'We-ee-wick, We-ee-wick, We-ee-wick'. By working throughout the night, the pig

Winwick Church.

succeeded in removing all of the stones that had been laid by the builders. The next morning, when the village leaders and church elders met, they decided that events of the previous night must have been an omen. It was agreed that the spot to where the pig had removed the stones must be the correct location for the new church to be built. The founder, feeling reproved for not having chosen that spot for the site of the church in the first place, decided to follow the wishes of the pig.

It would appear that the pig had not only dictated the location of the church, but had, unwittingly, given a name to the parish.

On the west side of the tower there is a carving of the 'Winwick pig' next to statues of St Anthony and St Oswald. Inside of the church there is a carving of a priest carrying two containers holding water from St Oswald's well, which is around half a mile to the north of Winwick at Hermitage Green.

Legends about animals having magical powers are known throughout Lancashire, especially in the Pendle area of the county. There is a similar tale told in Leyland, but instead of a pig the tale there relates to a magical cat.

Location: WA2 8SZ

 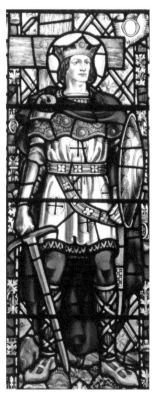

Above left: Statue of the pig on the church tower.

Above right: St Oswald.

The Earthenware Goose

In the Fylde country village of Singleton there once lived a toothless, hook-nosed old woman whose ugliness and solitary way of life was attributed to an unhealthy relationship with Satan himself. Many people in the village wished her dead because of her ugliness, but this didn't bother Meg Shelton, who saw it as a misfortune rather than a crime. She couldn't understand why children in the village were so afraid of her that they took off their shoes before venturing past her cottage. Before long everything that went wrong in the village was blamed on 'th' owd witch'. If the crops failed or a child fell ill, it was invariably Meg who was guilty.

As the days passed, every farmer in the area noticed that milk was disappearing – from the dairies and even from the cows' udders as they were grazing. As it was obviously Meg's doing, they decided to conceal themselves near her cottage and confront her when they had confirmation. No sooner had they hidden behind a hedge in front of her home than they saw the old woman coming out of the house with a cat and a goose following behind.

The men remained hidden until the old woman returned later on, but this time without her former companions. As she went to unfasten the door, the men emerged from their hiding place and seized her, but they found no evidence of her concealing a milk jug about her person. Meg was incensed and cried aloud, 'Will ye never learn to respect grey hair, ye knaves?' One of the men then asked her, 'What he's ta done with th' milk to-neet?' Then, quite by chance, the goose came waddling across the byway, causing quite a commotion and a welcome diversion for Meg. 'I thowt it quare,' said one of the would-be executioners 'varra quare, that th' goose worn't somewheer abaat, for hoo an' it's as thick as Darby an' Jooan'. As though sensing that something was troubling its mistress, the goose

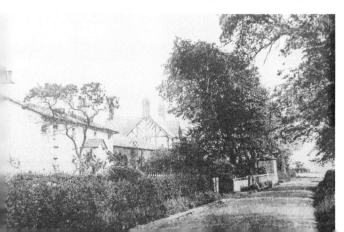

Singleton village.

Right: Fire station at Singleton.

Below: Fire station at
Singleton, 1907.

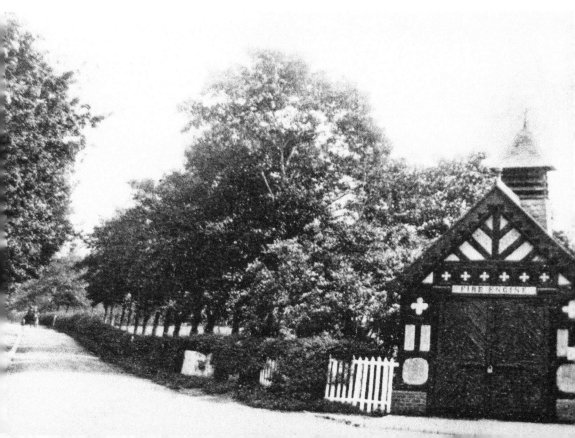

stretched its neck towards the bystanders and started to hiss very loudly before going to stand alongside her.

'We want no hissin' heear,' said the leader of the group, as he took a heavy stick and hit the goose sharply on the head. As soon as the blow was struck, the goose vanished – much to everyone's surprise – and in its place stood a broken pitcher from which warm milk was flowing.

After a few days, during which she was forced to endure unmerciful torment, the local vicar decreed that she should be allowed to leave the village without having to suffer further distress. She departed the next day, taking with her the cat and goose.

Sometime after she'd left, the landlord of the Blue Pig found that the jug he had given to the witch-watchers was missing. It was never seen again in its entirety, but the landlord was heard to suggest that the pieces found around the village were in fact fragments of the jug that had apparently materialised from Meg's transformed goose.

Later in life, Meg moved to Woodplumpton, where she died in 1705. It is thought that she was crushed by some falling barrels. She was buried in the village churchyard. But Meg's story doesn't end there; she was apparently seen on several occasions before finally being laid to rest, head first, under a large boulder in the churchyard, which can still be seen today.

Location: FY6 8LL

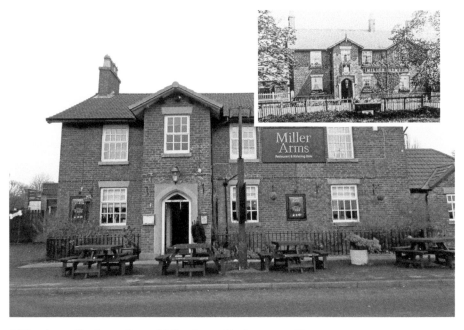

Miller Arms, Singleton. *Inset*: Miller Arms, Singleton, *c.* 1880.

Lostock Tower

Lostock Tower lies around 4 miles to the west of Bolton and has a number of legends associated with its history. The building was very imposing, surrounded by a deep moat and constructed in the traditional manner using wood and plaster. The gateway is all that remains of the older building that once occupied the site – the home of the Anderton family. The Anderton homestead itself was built of brick and stone, and featured large strong mullioned windows. On the front of the house there was a panel showing the family's coat of arms and the date '1591'. Elsewhere there was another panel over the doorway with the date '1702', perhaps indicating when the hall was extended or renovated. The hall

Lostock Tower.

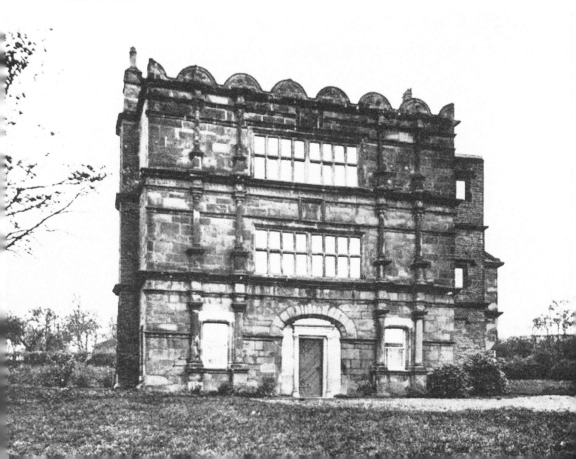

was built on low-lying ground, which often resulted in sheets of water covering much of the estate. Red Moss was also a boggy tract that also featured on the landscape.

Legend states that when the hall still belonged to the Andertons, a member of the Heaton family who resided in a neighbouring town bearing their name fell heavily into debt. In fact, the man was so deeply in debt that he was forced to mortgage his property to Anderton of the Tower. When the time came for payment to be made, it was obvious that the Heatons had not been able to raise the necessary amount of money. The day passed, and at a somewhat early hour the Andertons retired to their beds. They had not been long in bed when there was a thunderous knocking at the door; it was the Heatons. They had managed to scrape together the necessary cash and now wanted to pay off the mortgage due and reclaim their property, but the Andertons would not let them in, stating that the agreement clearly required the mortgage to be paid before the setting of the sun. The following day the mortgage was foreclosed and the terms of it were spelled out once again. The Heatons were ruined. The legend declares that until the property is restored to its rightful owners an Anderton ghost must revisit the scene of their duplicity. Further, while the property was still held by the Andertons, none of their horses could ever be induced to cross the stream that leads onto the illegally held property.

Another of the darker legends associated with the hall relates to the story of Oliver de Anderton, who it is said was murdered by his wife in 1466. For quite some time there had been a strong difference of opinion between Oliver and his strong-willed wife, Ellen, as to who would inherit; Ellen was adamant that it should be a younger son. As the disagreement was so profound, Oliver speculated that his wife was trying to poison him. This thought was confirmed in his mind just a few days later when one of his faithful dogs died shortly after eating some scraps from Oliver's plate. Looking now for an alternative to poisoning, it is thought that Oliver was killed by one of his sons at the instigation of Ellen, but when the plot was exposed Ellen took poison herself, rather than having to bear the ignominy of standing trial.

Location: BL6

The Pillion Lady

After a profitable summer's day at Garstang market, Humphrey Dobson decided that he deserved a well-earned drink at the Farmers Arms. Later that evening he left his friends and soon reached the point where the road crossed a stream; a stream reputed to be haunted by a woman who had been murdered at the spot many years previously. Feeling a little apprehensive, Humphrey rode on, although he did notice a dark spot just ahead of him overshadowing the trees. His mind began to play tricks on him as he thought of some of the stories he had heard in his youth: those of a headless woman whose sole occupation was to terrify travellers in that particular area. Undaunted, he sought to allay his fears with the words of an old song:

> He rode and he rode till he came to the dooar,
> And Nell came t'oppen it, as she'd done afooar:
> 'Come, get off thy horse,' she to him did say,
> 'An' put it i'th'stable, an' give it some hay.'

Casting any ill thoughts to the back of his mind, he galloped on towards the bridge. Then, as he approached, he heard a blood-curdling laugh coming from under the arch of the bridge. The next thing that he was aware of was an icy arm reaching around his waist and a slight pressure on his back. He could now feel

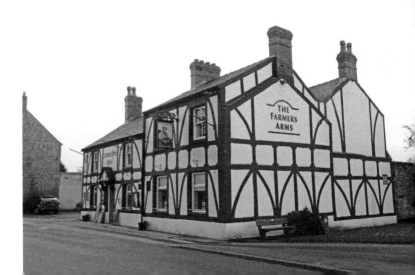

The Farmers Arms, Garstang.

Lane leading to the
Farmers Arms.

himself sweating and his heart was racing faster than ever before, but he was too terrified to glace behind him for fear of seeing 'th' boggart o'th' bruk'.

As they neared the farm he tried to guide his horse into the yard, but to no avail. Whatever he did the mare would not respond, and she raced on past the farm gate. As the farm was then fast receding Humphrey heard another spine-chilling laugh, but this time, as it was so close, he involuntarily turned around in his saddle. Much to his surprise, the figure behind him was not the headless being that he'd heard so much about, but a far more ghostly apparition. Looking out from under the hood that she was wearing, all that Humphrey could see was a grinning skull with eyeless sockets and gleaming white teeth. The ghastly skull was so close that it was almost touching his face. So alarmed was Humphrey that he couldn't turn his head away, but looked, transfixed, at the ghostly figure sat behind him.

As they sped on through the night, the ghostly pillion continued to chortle with her shrill laugh. Humphrey noticed that the arm around his waist was becoming tighter so he reached down to loosen it, only to find that the arm was no more than a skeleton. Humphrey had no idea as to how long his ghostly companion had been with him, but then – in a trance – his horse lost her footing at a bend in the road and stumbled and fell. Humphrey was thrown to the ground and lay unconscious for some time.

It was daybreak by the time he was regaining consciousness; the sun was shining, the birds were singing and his horse was standing some way off quietly grazing. Humphrey could not begin to contemplate the events of the previous night. Somewhat weak, tired and more than a little embarrassed, he made his way home to the farm. When he did arrive and retold his story to the gathered company, there were murmurings of disbelief; however, ever since that time no one from the farm could be induced to ride over the bridge.

Location: PR3 1PA

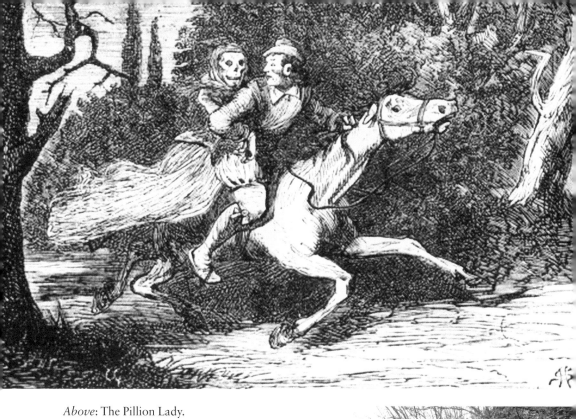

Above: The Pillion Lady.

Right: Lane leading out of Garstang.

The Fool of Lancaster

Many years ago in a little village just outside of Lancaster, there lived a ploughman and a butcher. For as long as anyone could remember they'd lived quite peaceably side by side, but then a trifling difference almost ruined both of them.

As the days had gone by it became apparent that there was no obvious solution to their dispute, so they eventually agreed that their case should be heard by a local lawyer. Unbeknown to each other, both of them bestowed gifts upon the lawyer, in the hope of gaining some advantage over the other litigant. The ploughman was the first to stumble on this ruse to gain advantage. He presented to the lawyer two prize hens, but took care to make the lawyer aware that he expected to receive favourable treatment at the upcoming lawsuit. It wasn't long before the butcher heard of the ploughman's gift to the lawyer and decided to offer a better inducement to him: a 'good fatte hogge'. The lawyer accepted the hog and promised the butcher that he would receive a favourable hearing, just like he had told the ploughman.

The day of the hearing drew near and it was eventually found in favour of the butcher, much to the chagrin of the ploughman. As soon as he heard the outcome, he made his way to the lawyer's to enquire as to what had happened to the two hens he'd gifted to him. The lawyer, calm and collected, replied that the 'fatte hogge' had eaten both of the hens. Whereupon the ploughman, in complete disbelief, replied that the hog had eaten not only the two hens, but also his lawsuit. There was no sympathy for the foolish act of trust that the ploughman had invested in the lawyer. On reflection, perhaps it was best to put it down to experience.

Location: LA1 2HP

Mother and Child

On the last night of November the tenants of Plumpton Hall, which lies around 2 miles east of Ulverston, always went to bed somewhat earlier than was usual. All of the rooms were in complete darkness and the house was silent as the grave, but none of the residents were asleep. Instead, they were all holding their breath and waiting for the first stroke of the hour. The deathly silence was suddenly broken by the sound of footsteps outside of the hall. Panic ensued for a minute, until the terrified listeners realised that it was a wayfarer on his way home. But their relief was short-lived. When the last stroke of eleven had chimed, the fearful residents heard the all too familiar sound of a heavy object bumping down the hall's stairs. Now terrified beyond belief, the hall's occupants all instinctively hid their heads under the bedclothes. They were aware that the heavy object bumping its way down the grand staircase was an old-fashioned oak chair.

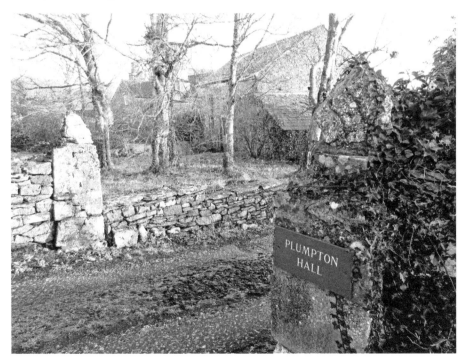

Entrance to Plumpton Hall.

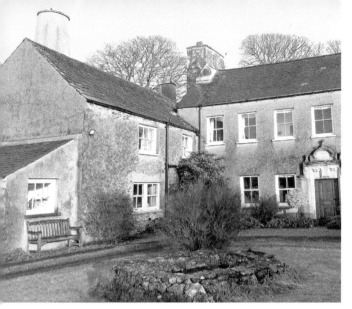

Above left: Plumpton Hall.

Above right: Rear of Plumpton Hall.

If any of the residents had ventured to follow the chair into the wainscoted parlour, they would have seen a huge fire blazing in the grate, even though the servants had ensured that the fire was extinguished before they retired for the night. They would have also witnessed a beautiful young woman sat in the chair near to the fire with an infant at her breast.

For many years on that date the glow of the fire could be seen coming from the haunted room, and the dulcet tones of a mother singing a lullaby to her child could always be heard. Many growing up in the service of the hall had heard the plaintive singing, but none had ever recognised the words of the song. Similarly, the servants had always found the grate as they had left it, with not even a cinder or speck of dust remaining after the ghostly visitation, and certainly no evidence of a fire having been lit overnight.

Many travellers when passing the hall on that night were drawn to the bright, flickering fire in the room that looked so inviting, but none could attract the attention of the young woman gently singing as she suckled her child. One traveller, on observing the homely scene, was attracted by the prospect of gaining sustenance and warmth after braving the elements on such an inhospitable night. He tapped on the window, but when there was no response he reacted by cursing the woman who was showing no compassion to a destitute traveller. Upon hearing his cursing, the young woman turned and focused her piercing eyes on him, rooting him to the spot. His terror-stricken face became fixed and his dark brown hair instantly turned white.

The following morning, a labourer on his way to work found the unfortunate traveller rigidly fixed and clinging to the casement window, never to venture forth again.

Location: LA12 7QN

The Rescue of Moonbeam

The legend of the rescue of Moonbeam took place in the shadow of Pendle. One night a young man named Reuben Oswaldwistle was making his way across the horseshoe meadow, towards the bend of the stream under Red Scar. His aim was to catch some fish for the next day's meal. After casting his lines, he sat down and enjoyed the grandeur of the surrounding countryside. As he relaxed he dozed off, but his senses were soon awakened when he heard footsteps. Much to his surprise, Reuben saw a little figure in front of him dressed in green, wearing a bright red cap and pulling behind him a large flat-topped mushroom. The dwarf cried out, 'Dewdrop, Dewdrop!' and another dwarf appeared from behind the trees. 'What's the matter Moonbeam?' cried the newcomer. 'This table is too much for me to cart and if the king's dinner is not ready in time then I'll have some explaining to do.' Dewdrop immediately rendered assistance and the two marched off, taking the 'table' with them. As the dwarfs continued on their way, Moonbeam was heard to say, 'I'm about tired of this. Every night the table is stolen and I've to find a new one for each dinner, and no thanks for it either. I shall emigrate if this continues.'

Stream by Red Scar.

They then heard the bell announcing dinner but they hadn't even got the table set. They darted off, leaving the mushroom where it was. Less than two minutes later they returned with plates and cutlery and placed them on the improvised table. Next, Reuben saw an elegantly dressed dwarf walking from behind a tree. His clothes were quite regal: a bright green vest, smart white shirt and a hat as bright as a red poppy. He was leading a beautiful lady with golden hair and wearing dress of damask rose. Behind this regal couple there followed a number of gaily clad attendants and a small group of musicians. The royal couple then enjoyed the festive board, which included ladybird soup, baked stickleback, roasted leg of nightingale and numerous other delicacies. The band played throughout the feast.

The king then made an announcement, saying that everything had been very enjoyable. But no sooner had he uttered these words, than the queen questioned why her chickweed wine had not been served during the dinner. In a matter of seconds Moonbeam was in the king's presence, lying prostrate on the floor and pleading for forgiveness. He was grabbed by the executioner, fastened to a stake and a bee was pressed against him, ready to sting. Upon seeing this Reuben was so incensed that he said if any more pain was inflicted upon Moonbeam he would knock off the king's head! Nobody took any notice, until Reuben's fist came down on the king's head. When Reuben lifted his fist, all he could see was crushed grass under it! The king, queen, all of their courtiers and even Moonbeam himself had disappeared.

As nothing was left, Reuben thought that at least he'd keep the mushroom. When he arrived home he told his wife of the happening, but she said that he'd been asleep rather than catching fish for their dinner. Smiling, she said she'd make a mushroom soup instead.

Location: BB8 7BN

Pendle Hill.

The Footprint at Smithills Hall

George Marsh was one of the three so-called martyrs in the reign of Queen Mary. The son of Mr George Marsh, he was born in or around 1575. Following his formal education at Bolton Free Grammar School, George Marsh settled in the area, married at twenty-five and farmed there until the death of his wife. Being a man of firm conviction and principle, in order to try to overcome the desolation at the loss of his partner Marsh sent his children to live with his father and became a student at the University of Cambridge. On leaving the university he took holy orders and was subsequently appointed as curate of All Hallows, Bread Street, London. He followed his calling for some considerable time, zealously proclaiming the Protestant faith, which he preached both in London and in his home county of Lancashire. Indeed, it was during one of his frequent visits to Lancashire that he learnt that one of the servants of Mr Barton of Smithills Hall, a magistrate, had been sent to look for him. Not being of the mind to avoid any proclamation of his faith, George Marsh made himself known, and was later examined before Mr Barton. To this day, in a passage near to the door of the dining-room there is a cavity in a flagged floor that resembles to the print of a man's foot. Legend declares that this cavity was caused by the martyr himself, who, being incensed by the accusations being made against him, stamped his foot hard on the floor to confirm his testimony. The imprint continues to serve as a memorial to the holy man, who, being unmercifully provoked by the taunts and persecutions of his examiners and in a fit of complete frustration, lifted his head towards heaven and appealed to God for the justness of his cause to be recognised, and prayed that some memorial of the justness of his cause might remain in the hall as a constant reminder to his enemies of their wickedness and the injustices they were perpetrating.

Sometime in the early eighteenth century and in the absence of their parents, two of the younger members of the family who were living in the hall at that time decided to throw the flagstone into the ravine behind the hall. No sooner had the stone been thrown away than strange clattering noises were heard throughout the hall. The noises were so loud that none of the family or any of their servants could rest in their beds. The clattering noises abruptly stopped when the stone was returned to its rightful resting place. Further, it was reported that in 1732 one of the guests sleeping in the green chamber at Smithills Hall – Mr John Butterworth of Manchester – saw an apparition in clerical dress with a book in his hand. Upon hearing this, the owner of the hall directed that divine service should be held in the hall's chapel every Sunday.

Location: BL1 7NP

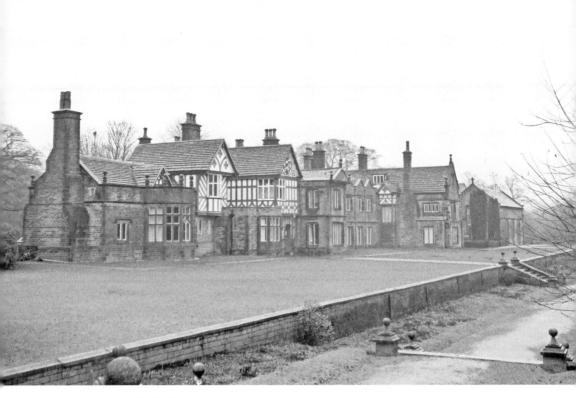

Above: Smithills Hall.

Below: Smithills Hall, *c.* 1935.

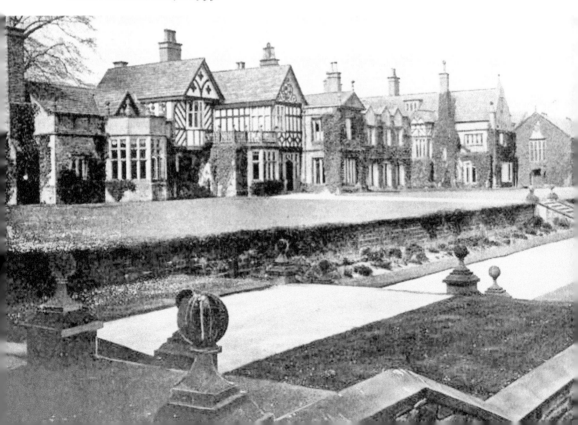

Old Sykes' Wife

In a secluded dell on the banks of Mellor Brook, near to the Old Hall of Samlesbury, there stood a farmhouse that was occupied by the Sykes family for many generations. They have long since died out, but the name lives on, if only because of the adventures of one member of the family. It is said that one of the last occupiers of the farmstead became very rich, partly because of the thrift of his wife, partly because of the hoarding of his ancestors, but mainly due to having discovering the hidden treasures of some former possessor.

The legend is told that in order to fight in the Wars of the Roses, which were raging at the time, all kinds of monetary problems were inflicted upon the population of Lancashire as a whole. As the Sykes' had no sons or daughters to pass their money on to, farmer Sykes' wife was only concerned about lawless marauders seizing it. She didn't want to become dependent upon the Southworths of the hall or the charity of the lordly Abbot of Whalley. She buried her treasure, secured in earthenware jars, deep under the roots of an apple tree in the orchard.

Time went by until, eventually, the Yorkists lost the ascendancy and the reins of government passed into the hands of the Lancastrians. When hostilities ceased, Henry VII sat upon the throne with Elizabeth of York as queen. It was during

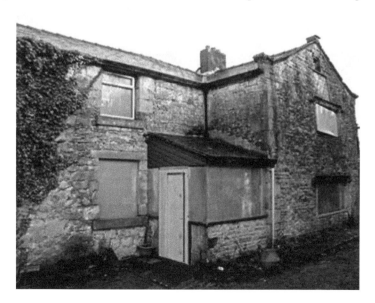

Sykes Farm,
Mellor Brook.

that time that Old Sykes passed away, leaving his widow as the sole possessor of their buried wealth, and it wasn't long before she too passed away. Unfortunately, because her death was very sudden, she had no time to tell anyone where she had hidden her treasure. However, her extended family had heard rumours of her supposed wealth and made lengthy and diligent searches in an effort to recover the hidden treasure, but they laboured without reward.

Over time, the farm passed into other hands. But old farmer Sykes' wife couldn't rest in peace, and her ghost paid many visits to the old farmhouse. Labourers returning from their day's work often spoke about a wrinkled old woman dressed in ancient garb, who walked along the road leading to the Lumb, but they were too afraid to talk to her. She often frequented the old barn and could also be seen in the farmhouse itself on occasions, but most of the time she was seen standing by the apple tree she had buried the treasure under. On one occasion, having had a few too many drinks, the owner saw the old woman standing in front of him and decided to confront her. She didn't say anything, just slowly moved towards the tree and pointed to its base. When a search was carried out the treasure was found, buried deep in the ground. As the last jar was unearthed, the old woman's form became less and less distinct until, ultimately, she disappeared altogether.

After the treasure had been found the ghost of the old woman was never seen again, her soul having found eternal rest – though many people are still too afraid to walk alone in the vicinity of the orchard.

Location: BB2 7PR

Ordinance Survey map of 1848.

The Sands of Cocker

Some time ago in the sleepy little village of Cockerham, just south of Lancaster, the Evil One himself was said to have taken up residence. The locals were not too pleased, especially when they heard the clanking of his chains as he prowled around the village, emitting malodorous sulphur-filled fumes as he went by. As the tiresome habit persisted, a number of the villagers decided that enough was enough. They volunteered the services of the schoolmaster to rid the village of this nocturnal rambler.

The schoolmaster set about his task with alacrity. That very night he stepped within a protective circle he'd drawn on the floor of his dwelling, holding a branch of ash and a bunch of vervain. He then began to repeat the Lord's Prayer backwards and immediately a mighty storm erupted. A flash of lightening lit up the darkened room, causing the frightened necromancer to try to recite the prayer normally, but he couldn't. There then followed a second terrible crash of thunder that shook the house to its foundations, and the schoolmaster saw a dark gentleman with piercing eyes standing at his threshold. Still within the chalk circle, the teacher witnessed the Evil One running around it and asking him in a harsh tone, 'Rash fool, what wantest thou with me?' The terrified schoolmaster managed to state 'Good Old Nick, go away forever'. But, fearing that he would be taken away with the Devil, the teacher inquired if there was any escape. Following the appeal to his fairness, Old Nick stopped dancing around the terrified teacher and addressed him: 'I'll give you three chances to escape; just set me three tasks, and if I should fail to perform any one of them, then you will be free to go without any harm.' The schoolmaster stood up inside his constraining circle and immediately agreed to the Evil One's conditions.

'For the first task, I'd like you to count every raindrop on the hedgerows from here to Ellel.' Satan immediately replied that the answer was thirteen, adding that all the others had been shaken off with the wind that he'd raised when he came over. This answer disheartened the despairing schoolmaster.

'What's the second task that you want me to perform?' The schoolmaster declared that the Devil should count every ear of corn in the tithe pig field. But, no sooner than the schoolmaster had issued his challenge, than Satan gave the answer as being 3 million and twenty-six. Totally distraught, the schoolmaster declared that he had no way of checking the accuracy of the figure. Satan merely shrugged his shoulders, as if to say that it wasn't his problem.

Knowing that it was his last chance to redeem himself, the teacher thought about the task that he should set. Finally, he said, 'The task that I set is to twist a rope of sand and then wash it in the Cocker without losing a grain.' Sensing victory, he was dismayed when the Devil returned with the rope of sand. As soon as the rope was dipped into the stream half of it was washed away, which didn't please the Devil. He crossed Pilling Moss and Broad Fleet, then vanished. As far as anyone knows, Cockerham has been free from satanic visits ever since.

Location: LA2 0ER

The White Dobbie

A long time ago in the Furness district of Lancashire, the villagers who lived along the coast between Bardsea and Rampside were troubled by a wandering soul who traversed along the lonely lanes each night, but nobody could ever ascertain as to why. Those who'd witnessed this nightly apparition testified to the fact that he looked emaciated and weary. He didn't seem bothered about enjoying the cosy life that the villagers enjoyed, keeping on his way, as if his very life depended upon it. Whenever the visitor appeared the women in the village could be heard crying, 'Heaven save us; 'tis th' White Dobbie,' drawing their children closer. There was always a scraggy-looking white hare present on these occasions that ran in front of the mysterious man, but as soon as anyone looked at the animal it jumped into his coat pocket and was lost from view. The villagers were aware that this was no ordinary hare and so were the animals in the village, who would scamper away for fear of coming face to face with the dreadful creature.

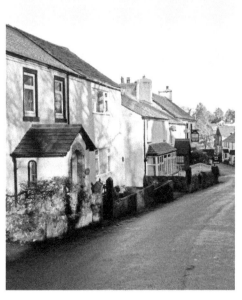

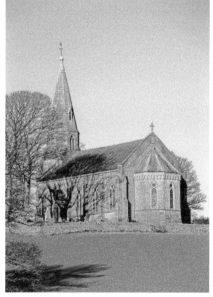

Above left: Bardsea village.

Above right: Holy Trinity Church, Bardsea.

Above left: The Olde Mill, Bardsea.

Above right: Road leading out of Bardsea.

It was known throughout Furness that the solitary wanderer had walked the byways for many years, but during that time nobody had ever heard the wanderer talking. One night, when there was a heavy mist over the bay, all that could be heard was the tolling of the Bardsea passing bell, proclaiming an imminent death in the village, but even the woman who had been the bell ringer for many years and the sexton was apprehensive as she stood in the tower lit only by a solitary candle. Every now and again she would pray aloud and tentatively look around her to see if everything was still as it should be. She felt very isolated in the church on the lonely hillside. All of a sudden she heard a whisper, which caused her to shriek in fear and although the church door was closed, she saw the red-eyed white hare running around the belfry. As the hare disappeared, she heard another whisper asking, 'Who for this time?' The terrified woman was unable to form an answer, but turned to her questioner. She looked upon the wild figure and saw the ghastly white animal staring up at her. She started to ring the bell once again. Then, all of a sudden, the church door burst open and some villagers entered the tower, having been alarmed at hearing the irregular pealing of the bell. When the villagers saw the sight in front of them, the red-eyed hare vanished and the wanderer glided out into the darkness.

The wanderer continued to visit the church over the coming years, but no one ever found out just why he had continued on his lonely pilgrimage. It was rumoured that the wanderer had murdered his lifelong friend, who was now embodied as the red-eyed white hare. For many years villagers along the coast were fearful of the legend.

Location: LA12 9QT

The Hulme Hall Treasure

Hulme Hall, a manor house adjacent to the River Irwell in Hulme, was the seat of a branch of the Prestwich family for many years. During the Civil War Sir Thomas Prestwich, who was at that time the owner of the property, fell upon hard times, mainly because of fines and sequestrations. Indeed, so dire was his situation that in 1660 he was forced to sell the hall and estate to Sir Oswald Mosley.

Sir Thomas' mother had, on many occasions, exhorted him to support Charles I by forwarding money to him to support his cause. She always assured him that she had ample funds to repay him, but these treasures were hidden. The location of the treasure – protected by spells and incantations, and known only to the Lady Dowager herself – was thought to be somewhere in the hall itself or in the surrounding grounds. As time passed the Lady Dowager became frail, so much so that she was neither able to practise the requisite incantations or confide in her son exactly where the treasure was hidden. Sometime following her burial an extensive search was made of both the property and the grounds, but no treasure was found. Sir Thomas died some years later in poverty. Since that time numerous searches were made in the hall and the grounds, but all were to no avail.

The hall and estate passed from the Mosley family and following a succession of owners the property was bought from George Lloyd in 1764 by Francis Egerton, 3rd Duke of Bridgewater. The hall was demolished in 1840 when the Bridgewater Canal was being constructed. At that time further searches were made, but no treasure was recovered.

It was always thought that the treasure was the property of the mother of Thomas Prestwich.

Location: M14 5RR

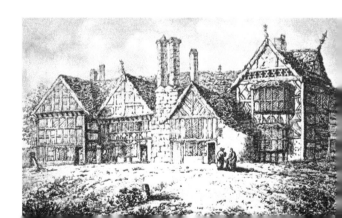

Hulme Hall by the River Irwell
(demolished in 1840).

The White Lady of Speke Hall

Speke Hall lies at the most southerly end of the old county of Lancashire. Construction of the current building started in 1530, although it is thought that there was a property on the site before that time. The hall has an oak frame resting on a base of local red sandstone, which is typical of the period. Built in stages and forming a quadrangle, the great hall was the first part of the construction (1530), followed by the great parlour, which was added the following year together with the North Bay. Some years later, between 1540 and 1570, the south wing was considerably extended. During that time the west wing was added in 1547. Finally, in 1598, Edward Norreys added the north range, thus completing the quadrangular architecture of the hall.

Over the years many legends relating to ghostly apparitions have been recorded, perhaps one of the most famous being that of the White Lady of Speke Hall. She

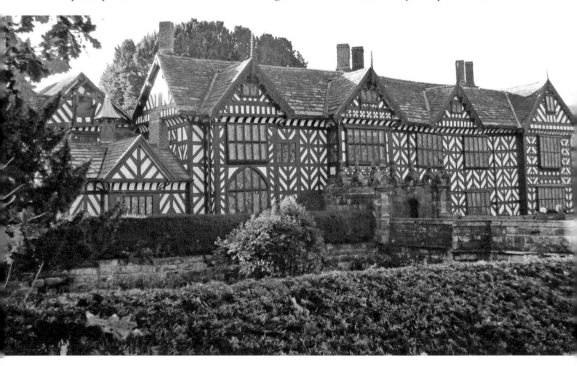

Speke Hall.

Speke Hall, *c.* 1850.

is thought to be Mary Norreys (Norris), a descendant of Sir William Norreys, the first owner of Speke Hall. In 1791 Mary inherited the hall and estate from her uncle, Richard Norreys. Sometime after inheriting the property, Mary married Lord Sidney Beauclerk. He, it is said, was an inveterate gambler and womaniser, spending much of his time away from the hall and mixing with high society in London. It is alleged that on one occasion he returned home after a long absence and calmly announced that his gambling debts had resulted in their financial ruin, leaving them penniless. Shortly after hearing this momentous announcement, coupled with his other alleged misdemeanours and philandering, and in a state of utter desperation, anger and fear of the future, Mary gathered her baby son, Topham, in her arms and threw him to his death from one of the windows in the tapestry room into the icy cold waters of the moat that surrounded the hall.

Shortly afterwards she too jumped into the murky moat. It is said that both died on that day, but records show that the baby survived and lived to an age of sixty-three years. Another version of the legend alleges that following her reckless act, Mary then calmly walked through to the great hall and killed herself.

In 1795 the Watt family bought the property and estate from the Beauclerks. It is said that Mary's ghost, known as the White Lady of Speke Hall, still haunts the property. She has been seen in both the tapestry room and the great hall, her spirit unable to rest in peace because of her remorse for killing her only child.

Location: L24 1XD

Above: Gardens at the rear of Speke Hall.

Below: Rear lawn at Speke Hall.

Ormskirk Church

The Parish Church of St Peter and St Paul in the small market town of Ormskirk is one of the larger churches in the area. There are fine views from the top of the tower looking towards the Irish Sea, with Liverpool towards the south and Preston to the north. The church is one of only three in England to have both a tower and a steeple incorporated into its architecture, and the only one to have them both located at the same end of the church.

There is much speculation that the town of Ormskirk itself derives its name from its parish church, and that prior to the building of Orm's kirk, or Orm's church, there was no other village or hamlet in Lancashire known as Ormskirk.

The earliest history of the church dates, in all probability, to the time of the Norman Conquest. It is thought that the founder of Burscough Priory, Robert Fitz-Henry, Lord of Lathom, gave Ormskirk (which had been inherited from his ancestor, Orm) as part of the endowment of the priory. If so, this would fix the date of the foundation of Orm's kirk, or church, towards the end of the eleventh or early in the twelfth century; however, some credence is still given to the belief that Orm himself actually erected the church shortly after the Norman Conquest. When he fled his estates in Cheshire, he married Alice, the daughter of Hervens, a Norman nobleman who owned extensive estates in Lancashire, and it was here they made their home. However, whether the church was originally built by Orm himself or by

Below left: Ormskirk Church.

Below right: Ormskirk Church, *c.* 1860.

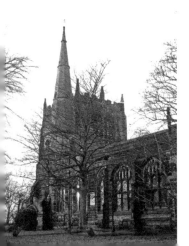

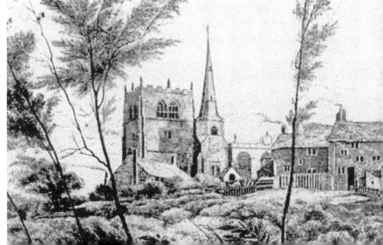

two of his female descendants is open to conjecture. The later legend relates to the more recently erected church, which it is said was built on the express wishes of two maiden benefactors of the great Orm family. Many consider that the women were sisters, but this fact has never been verified, nor has the legend regarding the unique nature of the building, which has both a spire and a tower. The weight of opinion, however, would suggest that because the two women could not settle as to whether the church should have a spire or a steeple, they agreed to disagree and built both.

Another prominent view suggests that the church was originally built with a spire, but upon the suppression of Burscough Priory in around 1536, a tower was built at the parish church to accommodate eight of the bells that had been taken from the priory as the small tower beneath the spire was not big enough to house them; the remaining bells were housed at Croston Church. The tenor bell at the parish church, which is said to have been the third at the priory, has a Latin inscription around the periphery: 'J. S. de Burscough, Esq., and E. my wife, made [this bell] in honour of the Trinity. R.B. 1497.'

Location: L39 3RD

Ormskirk Church as it is today.

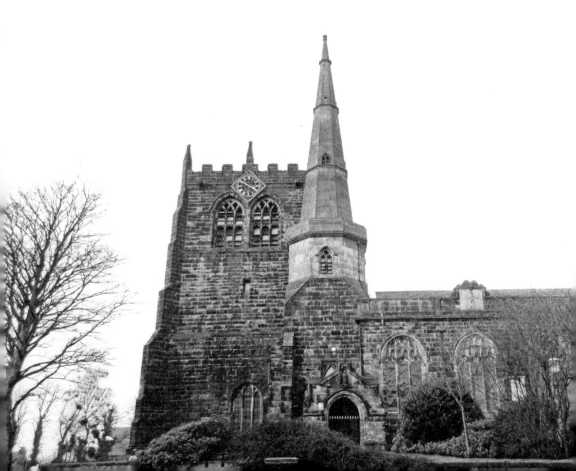

The Bannister Doll

The story of Dorothy, the Bannister Doll, is very rarely spoken of as many of the good people of Preston believe that even mentioning her name will bring back her tormented spirit.

During the early nineteenth century Mayor Bannister lived in an old tenement building in Snow Hill – near the town's Walker Street. Bannister's beautiful daughter was called Dorothy and was known locally as Bannister Doll due to her beauty. Being so attractive, there were many young men vying for her favours. It was therefore with some trepidation that Dorothy was faced with having to confess to her father that she was pregnant. Dorothy was fully aware that her father was a very strict man, but even she could not have foreseen the punishment that he meted out to her. Quite beyond himself in a fit of untold rage, he dragged her out of the house and tied her to a tree in the garden. He then proceeded to whip her until there was no more breath left in her. She was thought a disgrace to the family; although, later evidence would suggest that she had been victim of a vicious rape.

As the years rolled by new houses were built. A memorial stone was laid at the corner of Ladywell Street and Heatly Street, which was thought to be the place where 'Dolly' had been so brutally flogged to death. In order to instil in their daughters the virtues of being chaste, mothers would take their daughters to the spot and recount the legend of the Bannister Doll.

Snow Hill, Preston.

It is thought that Dorothy was buried in the grounds of Holy Trinity Church in Trinity Square, Preston, but there is some dispute about this. It was sometime after Dorothy had been laid to rest that the corpse of a young man was found near to the centre of Preston. The circumstances surrounding his death were a mystery to the authorities; his skull and ribcage had been crushed to pulp. Just two weeks after this dreadful event another young man's body was found, and he too had died in a similar manner. Later still there was a third body found. By now there were all kinds of rumours spreading throughout the town. Many held to the belief that the Bannister Doll had returned to the scene of her brutal murder to seek vengeance for the cruel and heartless way her father had murdered her. Although the spate of vicious deaths came to an end the many sightings of the Bannister Doll continued, with many people claiming to have seen the ghost of a young maiden floating up Snow Hill.

When Mayor Bannister eventually died another family moved into the house in which he had lived. On their very first night, they were accosted by the Banister Doll. They stayed for a second night and were once again subjected to the haunting presence of the ghost. They fled the house, never to return. The next family to move in stayed for three nights, but then they too fled the scene, having witnessed similar sightings.

Although the Bannister Doll is still seen on occasions, it is hard to reconcile the truly malevolent character that still haunts the town with the gay and carefree Dorothy who walked those same streets so many years ago.

Location: PR1 2XE

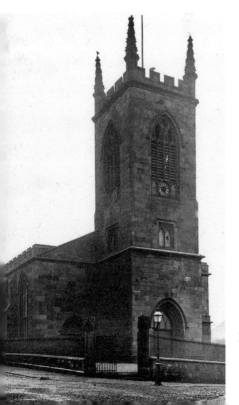

Holy Trinity Church, Preston (demolished in 1951).

The King of the Fairies

Between Manchester and Stockport there lived a farmer known as 'Owd Dannel Burton'. Daniel's was a model farm and his crops were the best raised in the area, but there were some people who were envious and began to spread evil rumours, suggesting that his success was due to something more than farming alone. One farmer whose crops had not been worth gathering, insinuated that he had sold himself to Satan. 'It's nob but luck,' said another farmer, 'mebbe it'll be my turn to-morn,' but the others who were there said that it was neither luck nor the Evil One. They did, however, speculate that it might have been the labours of Puck, King of the Fairies, who had helped to achieve Daniel's prosperity. As it happens, their speculation was quite correct, but Daniel was reticent to talk about it. The workers around the farm, however, were not quite as reserved and would often boast of the doings of their nightly visitor.

This continued for some time, until the services of the willing overnight worker were being taken for granted. One day when Daniel was eating his breakfast, a labourer brought news that all of the corn had been gathered during the night. Directly after finishing his meal he made his way to the field and found that it was quite bare, unlike the previous evening when the golden sheaves were standing proud.

The harvest was safely in the barn, but Daniel wanted to find out whose horses Puck had used. He was anxious to ensure that if his horses had been used they hadn't been worked too hard. When he saw the fairy, he confronted him: 'Puck, I doubt thou'st spoiled yon horses!' Puck flew into a range and shouted in a loud voice: 'Sheaf to field, and horse to stall, I, the Fairy King, recall! Never more shall drudge of mine stir a horse or sheaf of thine.'

The next morning Daniel was woken by one of his labourers, who exhorted him to come to the barn. When he got there he found that all of the corn that had been gathered was nowhere to be seen. He marched over to the cornfield, only to find that the sheaves of golden corn were stood there, just as they'd been the previous day.

After that time no more work was done around the farm by Puck, although the housemaids found that their work was still being done. Daniel became depressed as he walked around the farm, hardly realising that his misfortune was due to his own greed. One evening he bumped into one of his neighbours, who, during the

course of conversation, asked about the cause of his troubles. As soon as Daniel turned to point towards the meadows he espied the fairy stooping behind the hedgerow, intent on listening to the conversation. When the neighbour suggested that he missed the help, Daniel agreed and decided that he should make peace with the offended fairy king. Facing the fairy's hiding place, he shouted, 'And may God bless Puck, th' King o'th' Fayrees.' A loud cry came from the vicinity of the hedge, but there was nothing there. After that, all work around the farm and farmhouse had to be done by the servants. Puck, king of the fairies was never seen again.

Location: M14 6LA

Samlesbury Hall and the Lady in White

Someway between Blackburn and Preston there stands the old and famous Samlesbury Hall. It is located on a broad and rich plain of glacial drift. There are magnificent views from any aspect of the grounds, but the views to the east are truly spectacular, looking towards Ramsgreave, Billington and Pendle itself. To the west lies Preston and the broad estuary of the River Ribble, whereas looking in a north lies Longridge and the heights of Bowland. Many years ago, in the reign of Henry II, the property was the ancestral home of Gospatric de Samlesbury. It was from the abundant oak forest surrounding the property that huge timbers

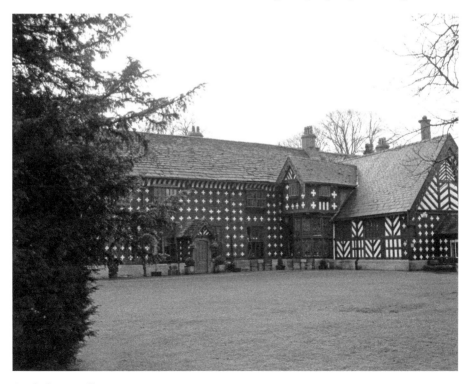

Samlesbury Hall.

Samlesbury Hall in former times.

were taken to form the stately structure, which was then erected during the reign of Edward III.

Sometime in 1275 Cecily de Samlesbury married John de Ewyas. But, upon his death there was no male heir, so the property and estate passed to his daughter, who had married Sir Gilbert de Southworth. The family then subsequently held the property for upwards of 350 years. The hall was then sold to the Braddyll family, and after that it passed into the hands of Joseph Harrison Esq. of Galligreaves, Blackburn; his eldest son, William Harrison Esq., continued to live in the hall for many years. Determined to restore the property to its former glory and its original design, Mr Harrison restored both the interior and exterior of the property until, finally, it was acknowledged as being one of the finest properties in the county.

The history progresses until, in 1562 during the reign of Elizabeth I, Sir John Southworth held the office of Sheriff of Lancashire. His many properties and estates included Samlesbury, Mellor and Southworth. However, not only was Sir John illiterate and self-willed, he was also a bigot. His rigid devotion to the faith of his ancestors caused him to speak impulsively and somewhat unwisely of the changes in the national religion. He also contravened many of the country's laws. He was detained in prison and treated harshly until his death in 1595. During his later years, one of Sir John's daughters fell in love with one of their close neighbours, but they needed to obtain Sir John's consent if they were to be married. When he was consulted, he was vehemently opposed to the union and most bitter in his denunciation of the proposed marriage. It was on the grounds of her suitor's religion that Sir John was so intensely opposed to the wedding, stating: 'No daughter of his should ever be united to the son of a family which had deserted its ancestral faith.' The young man was forbidden to visit the hall, but the lovers were determined to be together. So, unbeknown to her family, they often met in the wooded slopes leading down to the banks of the River Ribble. On one such occasion, they agreed that the best course of action would be to elope, holding to the fervent belief that the young maiden's father might pardon them for acting against his express wishes in time. However, one of her brothers

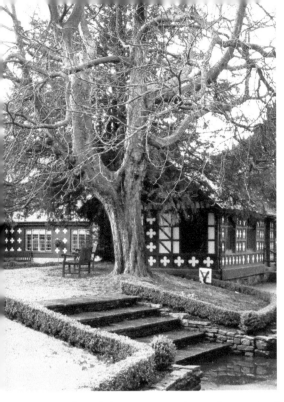

Above left: Entrance to the gardens at Samlesbury Hall.

Above right: Gardens at Samlesbury Hall.

was hiding in a nearby thicket and overheard their conversation and plans. He was determined to prevent her disgracing and humiliating the family.

On the night chosen for the elopement, the young knight together with his bride to be and two of his close friends, were set to leave the estate when suddenly Lady Dorothy's brother rushed towards them and savagely assassinated the young knight and his two friends. Their bodies were then taken to the domestic chapel at the hall and secretly buried. Lady Dorothy was sent abroad to a convent where she was detained under close supervision. In the fullness of time, and still grieving for the love that she had lost, her mind failed. Every day, all day, she could be heard repeating the name of her murdered lover. She died insane.

Many years after these gruesome events, the skeletal remains of three bodies were uncovered near to the domestic chapel. The remains were believed to be those of the knight and his two companions.

It's still the belief of most people familiar with Samlesbury Hall that on some nights a lady dressed all in white can be seen walking along the corridors and then out into the grounds of the hall, where she is met by her handsome knight. When they arrive at the supposed place of the lover's grave they stop and a soft despairing wailing can be heard. Following this, they embrace and then, gently fade from view as they disappear into the night skies.

Location: PR5 0UP

The Captured Fairies

Many years ago in the tiny village of Hoghton, near Chorley, there lived two good-for-nothing idlers. Every day from early morning until sunset they could never be seen working at their loom. While all of their neighbours were hard at work, these two idlers could be seen hanging around the local inn or playing dominoes to while away their time. Often, when they'd had a few drinks, they could be heard singing all manner of songs around the village. As they walked around the streets singing their bawdy songs, they were followed by two, very large evil-looking lurchers. Respectable people turned away in disgust, wondering what would happen to the idlers in the future. Very soon the lurchers were chasing after pheasants, but the vigilant gamekeepers shot them and in so doing rid the area of these unwanted visitors. It wasn't too long after this unfortunate event that the two men had their ferreting nets taken. Being poor they couldn't go out and buy new ones, nor could they ask their friends and neighbours to borrow their nets, as this would be tantamount to suggesting that their friends were poachers. Instead, they were forced to improvise using sacks whenever they visited the squire's fields.

Pub in Hoghton village.

Fields around Hoghton village.

One night the two men climbed over one of the squire's fences and found what they knew to be a well-stocked warren. They put in the ferret, tied the sacks over the burrows and very soon the sacks were jumping with life. They grasped the sacks around their necks and, with everything secured, made their way home. They weren't too sure what they'd trapped, but they were sure that it was a good haul, judging by the weight and the activity inside the sacks. After congratulating themselves, the poachers continued on their way. When nearly home, a sudden cry was heard coming from one of the sacks: 'Dick, wheer art ta?' Petrified with alarm, the poachers stood stock still wondering exactly what was happening. A few seconds later, a voice from another sack replied, saying: 'In a sack, on a back, riding up Hoghton Brow.' Terrified beyond measure, the men immediately dropped the sacks and ran home as fast as their legs would carry them. The fairies who'd been trapped in the sacks also needed to return home.

The following morning the two poachers returned to Hoghton Brow, only to find that the sacks had been neatly folded and placed by the side of the road. They picked them up and, after checking that there were no further surprises waiting for them, they returned home.

The would-be poachers were soon transformed into hardworking weavers, much to the amazement of the other villagers. Being regarded with such suspicion, the men were eventually forced into telling the whole story of the fairies' imprisonment. Word soon spread of the incredible transformation of the two men, who could always be seen working in the loom house, singing away: 'It's my delight, on a shiny night'.

Location: PR5 0DD

The Little Man's Gift

There are many wells throughout the ancient county of Lancashire that are said to be the dwelling places of evil spirits or, conversely, beneficent fairies. The Fairy Well, or Wrangdom Well, at Staining, Poulton-le-Fylde, was well known throughout the region because its water had miraculous powers of healing. Every day people came from near and far to fill their vessels with the amazing liquid. One morning, an old woman had journeyed there so she could get some water to bathe the eyes of her young daughter, whose sight was fast failing. After trying several different remedies, the woman was beginning to fear that her daughter would soon be blind. After filling her flagon, she noticed there was a little man clad in green stood nearby. As she stood looking at him he approached her and presented her with a small wooden box. He said that the ointment in the box, if gently applied to her daughter's eyes, would restore her sight. She wondered how he knew about her family's troubles, but nonetheless accepted the gift. When she looked over to thank him, he had disappeared so she started on her journey home. She had some misgivings on the way and wondered if the ointment had been given to her by one of the bad fairies, and if it might do more harm than good.

When she told her husband they agreed not to administer any ointment until its efficacy could be verified. The anxious couple waited for some sort of signal, but when none was forthcoming the distraught mother decided to apply the salve to her own eyes. When nothing untoward happened she administered the ointment to her daughter, but didn't tell her husband what she had done. During the following week the little girl's eyesight gradually improved, until it was time to tell her father the good news.

Over the years the daughter's eyes never failed, so the curious episode was almost forgotten. Until, that is, one day when her mother was shopping in Preston market she spotted the little man who had given her the ointment; he looked to be stealing corn from an open sack. As the woman was overjoyed to see him, she couldn't stop herself from going over and thanking him for his goodness to her and her family all those years ago. The little man, far from being pleased at her untimely intervention, was very annoyed with her and asked why she had tested the ointment on herself before administering it to her daughter. He then turned, struck her and immediately disappeared, as did the vision from one of her eyes.

Fortunately, the eyesight of the woman's daughter was not affected, but she was very careful not to say anything to the fairies whenever she saw them around, even when she could see them stealing.

Location: FY3 0BX

The Written Stone

Written Stone Lane crosses Lower Road around 2 miles from the village of Longridge. Originally an old Roman road, it takes its name from the large slab, measuring some 9 feet by 2 feet wide and almost 1 foot thick, and lies by the roadside. The inscription on the side facing the road reads: 'Ravffe : Radcliffe : laide : this : stone : to : lye : for : ever : a.d. 1655.' Legend alleges that a cruel murder was committed on this spot many years ago. The stone is said to have been placed there to appease the restless spirit of the deceased, which remained long after the body had been committed to the earth.

One night after attending a patient, a local doctor recounted that as he was approaching the stone on his way home his horse shied and then surged forward at an alarming pace, totally outside of his control. When the horse did stop, the doctor found it was covered in blood, which he couldn't account for.

Sign for Written Stone Farm.

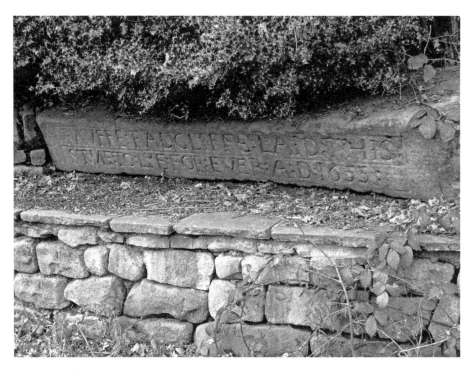

Above: The Written Stone.

Left: Written Stone Lane.

Sometime later another doctor (or perhaps even the same one) agreed to ride to the stone in an effort to disprove the legend, stating that he would not meet with any harm. He returned sometime later in a state of utter distress and shock, unable to relate the horror he had witnessed. Later that night, he stated that he had been dragged from his horse by some sort of shapeless mass, and that he had then been squeezed so tightly he almost died. Other travellers passing the stone often reported receiving bumps and bruises from an unseen assailant. Eventually, a service of exorcism was held at the site.

Many years later, the then owner of Written Stone Farm, not knowing the story of the legend, decided that it would serve as a particularly good 'buttery stone', but when he came to move it into the farmhouse it took a team of six strong horses to complete the move. The move did not prove to be beneficial, however, as this action unwittingly served to release the spectre once again, thus causing all kinds of mischief around the farm. Every time the kitchen utensils were placed on the stone their contents were invariably tilted and spilled all over the floor; the vessels would continue to bang and clatter throughout the remainder of the night. The farmer eventually realised what was happening and decided to return the stone to its original location on the road outside of the farm. Remarkably, it only took one of his horses to perform this task. After this was completed, the noise immediately stopped and the farmer and his family were never again subjected to any ill treatment.

Location: PR3 3ZA

Turton Tower

Without any doubt, Turton Tower is one of the most interesting buildings in the area of Bolton. It is believed that the manor was gifted to De Orell at the time of the conquest of England by William himself for military services rendered.

Paying his workmen only one penny a day, De Orell had built a fortified mansion, which later became known as Turton Tower. The building was so lavishly appointed that even paying such low wages to the workmen, the family never recovered financially from the tremendous outlay. Ultimately, the Orrell

Turton Tower. *Inset*: Turton Tower, *c*. 1845.

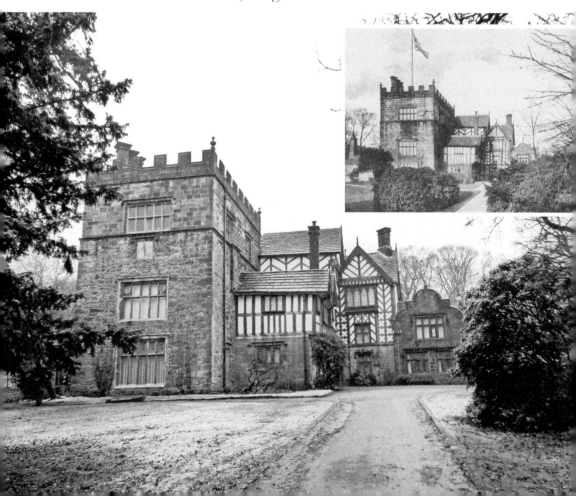

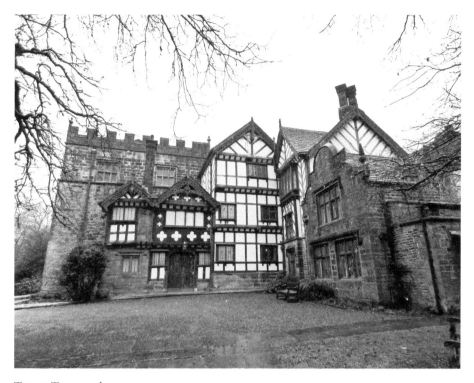

Turton Tower today.

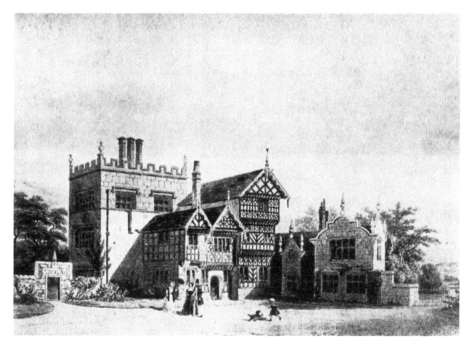

Turton Tower, *c.* 1820.

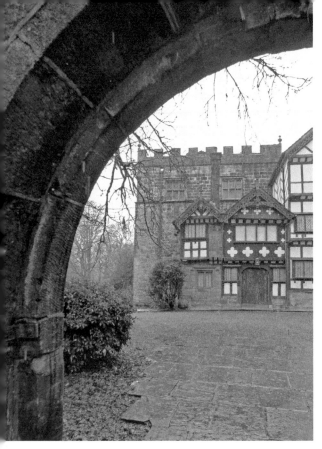
Side entrance to Turton Tower.

family sold their estate to Humphrey Chetham and later James Kay Esq. of Pendleton, who restored it to its original design.

It is said that the tower is haunted by a lady who passes along the corridors and into various rooms. The lady is thought to be dressed in a stiff white silk dress, but she is never actually seen. On her regular visits she often sweeps from the main hall, up the broad staircase and into the upper rooms. When taking this particular route the sound of her dress brushing against the staircase is said to be even more distinct.

Another legend associated with the tower relates to a nearby farmhouse known as Timberbottom, or the Skull House. The name derives from the fact that two skulls were kept at the house; one was clearly very old and much decayed and the other appeared to have been severed by a blow from a sharp instrument. The legend of the house declares that if the skulls are ever removed, the inhabitants will never be at peace. On more than one occasion the skulls have been buried in the graveyard at Bradshaw Chapel, but for the sake of peace and quiet, they have always had to be exhumed and returned to the farmhouse. It has also been recorded that the skulls have been cast into the nearby river, but before too long they had to be fished out and taken back to their rightful resting place in order that the ghosts of their owners could once again rest in peace.

Location: BL7 0HG

Select Bibliography

Axon Ernest, *Bygone Lancashire* (Simpkin, Marshall, Hamilton, Kent & Co. Ltd: London, 1892).

Axon William, *Echoes of Old Lancashire* (William Andrews & Co.: London, 1899).

Bowker James, *Goblin Tales of Lancashire* (W. Swan Sonnenschein & Co.: London, 1883).

Camm Dom Bede, *Forgotten Shrines* (MacDonald and Evans: London, 1910).

Dowdall Mary, *Lancashire Legends* (Constable and Co. Ltd: London, 1911).

Farrer William, *The Victoria History of the County of Lancaster* (Constable and Co. Ltd: London, 1911).

Fishwick, Henry, *Memorials of Old Lancashire, Vol. 2* (Bemrose & Sons Ltd: 1909).

Grindon, Leo H., *Lancashire: Brief Historical and Descriptive Notes* (Seeley & Co. Ltd: London, 1892).

Harland, John, *Lancashire Legends* (George Routledge & Sons: London, 1873).

Harland, John, and Wilkinson, T. T., *Lancashire Folk-Lore* (Frederick Warne & Co.: London, 1867).

Landreth, Peter, *Legends of Lancashire* (Whittaker & Co.: London, 1841).

O'Donnell, Elliott, *Dangerous Ghosts* (Rider & Co.: London, 1954).

Roby, John, *Traditions of Lancashire* (George Routledge & Sons: London, 1872).

Taylor, Henry, *Old Halls in Lancashire and Cheshire* (J. E. Cornish: Manchester, 1884).

Waugh, Edwin, *Lancashire Sketches* (Simpkin, Marshall & Co.: London, 1869).

About the Author

David Paul was born and brought up in Liverpool, when it still fell within the Lancashire boundary. Before entering the teaching profession, David worked in Liverpool for many years. Since retiring, David has written a number of books on different aspects of the history of both Liverpool and Lancashire.

ALSO BY DAVID PAUL
Speke to Me
Eyam: Plague Village
Around Speke Through Time
Woolton Through Time
Anfield Voices